THE
FUTURE
OF AFROFUTURISM, BLACK COMICS, AND SUPERHERO POETRY
BLACK

EDITED BY LEN LAWSON,
CYNTHIA MANICK,
AND GARY JACKSON

BLAIR

Printed in South Korea
Cover design by Zaire McPhearson. Interior design by April Leidig.

Blair is an imprint of Carolina Wren Press.

 *The mission of Blair/Carolina Wren Press is to seek out, nurture,
and promote literary work by new and underrepresented writers.*

We gratefully acknowledge the ongoing support of general operations by the Durham Arts
Council's United Arts Fund and the North Carolina Arts Council.

Lucille Clifton, "further note to clark," "if I should," "note passed to superman," and "it
was a dream" from *The Book of Light*. Copyright © 1993 by Lucille Clifton. Reprinted with
the permission of The Permissions Company, LLC on behalf of Copper Canyon Press,
coppercanyonpress.org.

Gary Jackson, "Nightcrawler Buys a Woman a Drink" and "Luke Cage Tells It Like It
Is" from *Missing You Metropolis*. Copyright © 2010 by Gary Jackson. Reprinted with the
permission of The Permissions Company, LLC on behalf of Graywolf Press, Minneapolis,
Minnesota, graywolfpress.org.

Yona Harvey, "In Toni Morrison's Head" from *Hemming the Water*. Copyright © 2013 by Yona
Harvey. "Q" and "Dark and Lovely After Takeoff (A Future)" from *You Don't Have to Go to
Mars for Love*. Copyright © 2020 by Yona Harvey. All reprinted with the permission of The
Permissions Company, LLC on behalf of Four Way Books, fourwaybooks.com.

Terrance Hayes, "Shafro" from *Muscular Music*. Copyright © 2006 by Terrance Hayes,
published by Carnegie Mellon University Press; originally published by Tia Chucha Press,
1999. "American Sonnet for My Past and Future Assassin" from *American Sonnets for My Past
and Future Assassin*. Copyright © 2018 by Terrance Hayes, published by Penguin Books.

Amanda Johnston, "Blade Speaks at Career Day" was previously published in *Kinfolks
Quarterly*.

Cynthia Manick, "Dear Superman" was previously published in the *Cortland Review*, and
"Praise for Luke Cage's Skin and Starshine" was previously published in *Cosmonauts Avenue*.

Gil Scott-Heron, "Whitey on the Moon," by permission of Brouhaha Music Inc.

Tracy K. Smith, "Sci-Fi," "My God, It's Full of Stars," and "The Universe: Original Motion
Picture Soundtrack" from *Life on Mars*. Copyright © 2011 by Tracy K. Smith. Reprinted
with the permission of The Permissions Company, LLC on behalf of Graywolf Press,
Minneapolis, Minnesota, graywolfpress.org.

All other poems by permission of the author

All art courtesy of the artists

ISBN: 978-1-94-946767-3

Library of Congress Control Number: 2021942511

The Sun Burnt Up and Other Reasons to Riot

Walk with me
out of the mouth
of this dark holler
we may never leave
this star alive
again

—Sheree Renée Thomas

Contents

BLACK HISTORY

NEW FAITH CONSTRUCTS

Introduction from the Editors

Afrofuturism at its core is invading spaces that purport Blackness as inferior. At its nucleus, the Black imagination has always been futuristic because it yearns for its roots in Africa, the place that birthed it, where communion with the supernatural originated in tribal culture—I had a vision to track that pilgrimage with Afrofuturism and poetry back to those places I left behind as a kid in front of the TV, in the classroom, at the library, or just trying to embody whiteness when I never should have. The result is *The Future of Black*, an explosion of poetry gathered over decades that speak to an Afrofuture that has existed since enslaved people believed their own could fly away from plantations to escape the whiteness I craved. This is a moment in time that I am proud to say I chased and did not allow it to vanish. In many ways, I am still that kid preparing a bowl of cereal after dawn on Saturdays, sitting akimbo in front of that RCA floor model, trying to see in these poems where I can find myself in my own future. *The Future of Black* includes my poetry heroes, my comics and movie superheroes, and heroes-in-waiting who are emerging poets and artists. Blackness is so strong in this work. Honestly, Blackness has always been strong. Assembled with my fellow editors, I am proud that we can offer this Black power device into the palms of others who, like me, may mistake whiteness for the sun despite the radiance of an Afrofuture. I thank Gary, Cynthia, and the publishing team at Blair along with the host of poets and artists lending their work to this project for catching this vision toward a palpable, vibrant future for our culture.

—*Len Lawson*

My first fluency was the elements, as I thought the sun was following me. Then the moon was keeping watch. When I cried, I thought it must've rained somewhere. As I grew older, reality set in and I realized that the elements had nothing to do with me. But then came Ororo Munroe, aka Storm, from the X-men, a beautiful Black woman who could fly and push clouds back with her eyes. There I saw the power of fantasy and imagination where anything was possible. In media, literature, and in life, the Black collective has always been told "you're too much." That we laugh too loud, sing too high, dance too hard, or dream too big. Afrofuturism counters that and becomes both a balm and a revolutionary act as we imagine ourselves with the stars, bulletproof, and in every scene the light hits our dark skin luminous. In *The Future of Black*, every poem and image illuminates. It subverts traditional canon with superheroes, antiheroes, cultural commentary, reimagined backstories, and alternate worlds. This collection is pulling up the B-side of a camera roll or album. Who knew Lucille Clifton wrote poems to Superman? This collection is doing Soul work where nothing is too much, but just right. I thank all the contributors and Blair Publishing for allowing me to help in that process.

—*Cynthia Manick*

T*he Future of Black* is a collection of more than sixty artists, writers, and poets imagining distant and not-so-distant future landscapes, reclaiming our histories, remixing established heroes and icons while creating new ones, and illustrating the everyday disasters and miracles of what it means to be Black today, tomorrow, and yesterday.

But these poems are not meant to represent some monolithic block of Blackness. This anthology represents a wide range of aesthetics and voices where you'll (re)discover established and upcoming authors; encounter poems you may have read before in new contexts alongside brand-new work; and view illustrations by artists you may otherwise be familiar with in the four-color worlds of comics.

Many thanks to the crew at Blair Publishing for giving this book a home, and infinite gratitude to the many contributors who were willing to assemble in the following pages to bring this vision to life. Our hope is that this anthology offers multiple salves: words that call to action, images to inspire, a little escapism, and an invitation to join us in forging our own fantastic futures.

—*Gary Jackson*

MAN OF STEEL

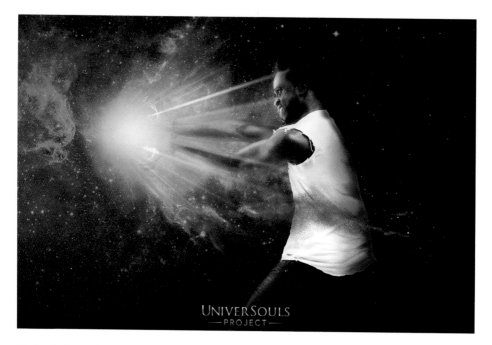

Unleashed, Borelson

if i should

enter the house and speak
with my own voice, at last,
about its awful furniture,
pulling apart the covering
over the dusty bodies; the randy
father, the husband holding ice
in his hand like a blessing,
the mother bleeding into herself
and the small imploding girl,
i say if i should walk into
that web, who will come flying
after me, leaping tall buildings?
you?

further note to clark

do you know how hard it is for me?
do you know what you're asking?

what i can promise to be is water,
water plain and direct as Niagara.
unsparing of myself, unsparing of
the cliff i batter, but also unsparing
of you, tourist. the question for me is
how long can i cling to this edge?
the question for you is
what have you ever traveled toward
more than your own safety?

final note to clark

they had it wrong,
the old comics.
you are only clark kent
after all. oh,
mild mannered mister,
why did i think you could fix it?
how you must have wondered
to see me taking chances,
dancing on the edge of words,
pointing out the bad guys,
dreaming your x-ray vision
could see the beauty in me.
what did i expect? what
did i hope for? we are who we are,
two faithful readers,
not wonder woman and not superman.

note, passed to superman

sweet jesus superman,
if i had seen you
dressed in your blue suit
i would have known you.
maybe that choirboy clark
can stand around
listening to stories
but not you, not with
metropolis to save
and every crook in town
filthy with kryptonite.
lord, man of steel
i understand the cape,
the leggings, the whole
ball of wax.
you can trust me,
there is no planet stranger
than the one i'm from.

new note to clark kent

after Lucille Clifton

even you
are not hero enough
to lift half this country out from under so much
ignorance

not with fake news and alternate truths tweeted
around the planet daily tongue-tying the daily
planet.

you can beat batman, bare-handed, but because dark money
be bigger

you powerless against the kryptonite of rich man and hate
man

and if orange man was a comic character, if lex luthor had comb
over hair he would be elected president and DC would
immediately repeal marvel

while you and an army, all white, all male, all
privileged fall out of the sky
on sunday talk shows
insisting the sky isn't falling

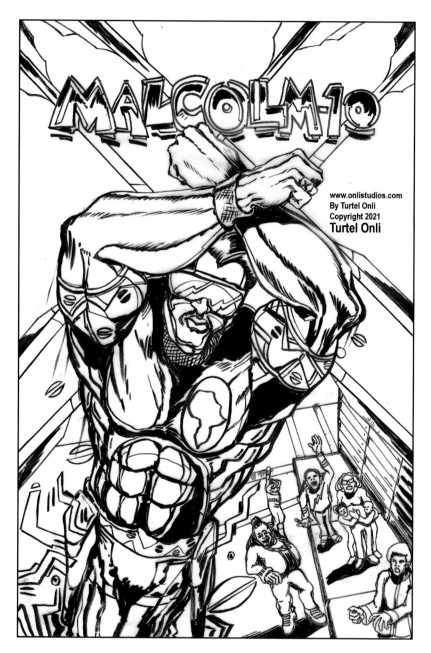

M10, Turtel Onli

Superman Retires

But let the world dream otherwise,
We wear the mask!
—*Paul Laurence Dunbar*

my father my lone superman drove
his cutlass supreme always pristine proud
right-fist-pumping in the air high above
his salt & pepper afro pride nostrils flared
& ready his fight never-ending to just be
a *man* not *boy john* not *jack mister*
not *nigger* his kryptonite & dynamite

home at night his redblackgreen cape hanging
coltrane's saxophone wailing in the backdrop
beat-up knuckles soothed unclenched
hands around my mother's petite waist
my sister & me at his exhausted feet
his tenderness his exact strength
carefully concealed from metropolis.

Ashley M. Jones

Superman's Girlfriend Lois Lane No. 106

using words from the comic book

on this daily planet, my life is good luck, all supermen at my service—
I should get the pulitzer prize on the backs of metropolis' black
community / wait / tenements perplex me—how can I break through
this plague, their suspicious speech, these slick-mouthed babies and
their knock-slam slang // homeless ghosts on this daily planet, what is the
reason for their weary report / look how the sun shines sweet and pretty
on their rat-infested slums // it's okay, I'm right / I'm whitey, never forget //
Little Africa is dejected, a neighborhood of frustration / I'll step into this
machine and transform, a startling switch / Black for a day only / the
hum zoom of the world staring / the smoke of white fragility / its gloomy
firetrap // Black is beautiful / have you met it before, reporter / the eternal
struggle of life against death by darkness / a life of *please*, look me straight
in the eye / the constant confrontation of being Black and alive in a white
man's world / a universal outsider // so alien, even Superman couldn't
risk loving you//

Dear Superman

Tell yourself what you will
that you wait patiently
to tip your Clark hat and jaw
to every Sara, Lois, or bright
haired Jane. Women with coiffed
hair, pink lips, and cosmetics
lightly placed. Delicate shades
that blush so nicely on paper,
TV, and high resolution film.
But I see how the animal
of your body passes by
the dark girls. Girls with names
like Esther, Jaleesa, or Cantina
Rose. Girls who wear glasses
and dresses with the slip showing.
Women of strong flavors—
hot peppers between their legs
and a storm inside. Those girls
secretly stir you from liver to toenail.
And they too crave strong arms—a cape
to cradle inside, and have dreams
of sleeping between stars.

MORE SUPERHEROES

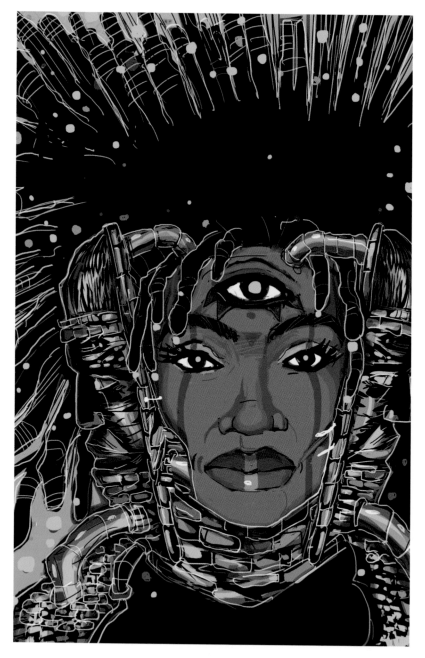

Afrofuturism, John Jennings

Nightcrawler Buys a Woman a Drink

You're staring, jaw-dropped at my tail. And yes,
it's a good twenty inches long and moves

like a serpent in heat. Touch it. I'm no devil, honey,
I don't got no souls, just the smoothest, bluest fur

you've ever seen. Don't mind my buddy here, he looks angry
all the time, and he's got eyes for the bottle of Jameson

and the short-haired blonde playing pool near the gorillas.
What do we do? Over a few drinks I could tell you about the time

we traveled to the blue side of the moon or when we fought
the Juggernaut right here in this bar. Yeah, the fangs are real.

Rub your finger over them, touch the deviled tongue.
Caress my fur with your skin, let me keep your body warm

in the dark. It's your night, honey. Show me a woman not afraid
of a mutant man. Let me mix into your bloodline.

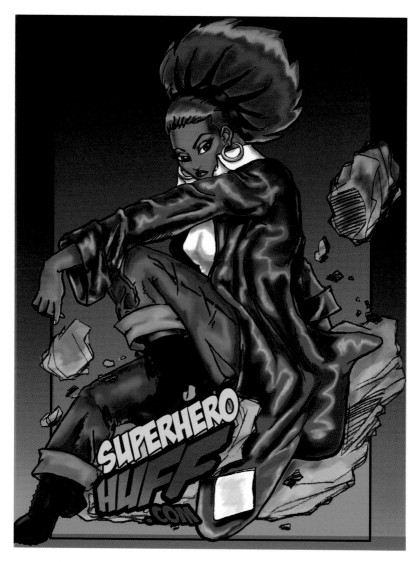

Superhero Huff, Yorli Huff

The Flash Reverses Time

When I'm running across the city
on the crowded streets
to home, when, in a blur,
the grass turns brown
beneath my feet, the asphalt
steams under every step
and the maple leaves sway
on the branches in my wake,
and the people look,
look in that bewildered way,
in my direction, I imagine
walking slowly into my past
among them at a pace
at which we can look one another in the eye
and begin to make changes in the future
from our memories of the past—
the bottom of a bottomless well,
you may think, but why not dream a little:
our past doesn't contradict our future;
they're swatches of the same fabric
stretching across our minds,
one image sewn into another,
like the relationship between a foot and a boot,
covariant in space and time—
one moves along with the other,
like an actor in a shadow play—
like a streak of scarlet light
across the skyline of your city
sweeping the debris, which is simply confetti,
candy wrappers, a can of soda,

all the experience of a day discarded
and now picked up
even down to the youthful screams of play
that put smiles on the faces of the adults
who hear remnants of their own voices
through a doorway leading back
to a sunrise they faintly remember.

Aubade on Bachelorhood and
Never Becoming the Flash

they say that if i were able to run at the speed of light,
(or god willing past it)

time would curl on itself like leaves after their tails in a
fire. imagine the spokes

of a wheel reversing as you watch it, a swallow glancing in your path, and
transforming—a bullet fired forward on a tether

stretched to the limit and thrown back into his shell. to have
access to the place nostalgia goes to slink,

like Sampson enchained. to see clumps of sugar hang like
organs

in the cathedral of the sugar jar, the histrionic sun, and our
fingers braiding then unbraiding. in the divine verticals.

our bodies wed other orbits of love. forever

is for the mind and not the body. there are many ways to die,
they say. i find it difficult to believe. for any of us, you
know, there is only one.

Blue Dick Blue Balls

I just ate an egg
And tried to walk
On water but busted my ass
In the tub.

I'm not going to
Speculate. I
Don't have to, yo.
I exist in all time.

Past present future
All collide in my mind.
Ask my wife. Married her
Before we met. Regular riot.

Though I must admit, it's a
Little embarrassing. Me in this
Tub and all—flat on my arse. Oh,
God. Where's my watch, mane?

My enemies will pay
A price for vaping my
Blue-black Blackness,
Leaving me with no soap.

No squid pro quo for all the shit I did
For this damn planet. I'm not asking
For reparations. Just acknowledgment
And some drawers.

Princess Diana of Themyscira, Aka Wonder Woman

She's a wonder of a woman ravished by beauty—
78 years of age. No wrinkles. No fat. No pressure
for perfection, already more perfect
than a department store mannequin.
Puberty never scarred her face
with blotches, blemishes, blackheads.
I do not buy her T-shirt.
The power of her shield too flimsy
to resuscitate the past of a bruised little girl
who wears a vacancy sign each day
where innocence used to live.
Each day she fights the myth
you're not enough because of your body
docked inside skin that blends with the night.

II
Di's a cougar prowling
through this ceaseless jungle of time.
Emerges on the other side
with no scratches, scars, scabs of aging.
No ripples of cellulite on her butt or thighs.
Years sit heavy on my body.
Each day this receptacle of years
carries cancer relics.
The right breast a full cup smaller than the left,
lashless eyelids and swollen arm are souvenirs
of chemo's crushing embrace.
Is this jealousy irrational?
I squeeze into a pair of tight jeans,
put on black knee-high boots, walk
like the princess my father never told me I am.

BLACK SUPERHEROES

Superhero Huff, Yorli Huff

Ode to Static

for Dwayne McDuffie

Look, it was nice to know
Urkel wasn't the only choice we had

in our orbit. Another black nerd with covalent
cool we could share, a diasporic subatomic

dap, we loved you like Rakim verse
vibing every Walkman on the block. Static,

even your government name said classic
guide: Virgil Hawkins. We were in the dark

woods of spinner racks, mostly in a blizzard
of Ubermensch pulping the new born '90's pages.

And there you were, floating on a trashcan lid,
unashamed, spitting game to fine sistas

like the glow up of Oscar the Grouch. O blue
body-suit and fitted cap. O gold overcoat

like a return of the Mack. A look 3 Stacks
might sport on an album cover. You were out

saving citizens in style. Uptown fades slicked
every head. We understood the buzz

of a tape rewinding of only being
mentioned in the news via mugshot,

so we sought other panels, comic books, the mirror
you held up to our future. Static you were a milestone

for kids like me, whose brown skin
ran the whole gamut of electro-spectrum

Bruuuuuh or When Brothers Debate Black Panther in a Safeway Parking Lot.

A found (Overheard poem)
—Hyattsville, Maryland, February 2018

Bruh #1
But they corny though!
Ain't never wore any African gear in they life!

Bougie asses out here shopping to dress up for a movie.
This joint created by two white dudes. Marvel

getting all your money! Head wraps and shit. It's sad
seeing people get all excited for a movie.

They ain't been to Africa & ain't going. Kids
dressing up. That cos-play shit out of control . . .

Bruh #2

For real!? Ain't nobody say shit
when you wearing your lil personalized Skins

jersey or your Kirk Cousins jersey to work
after the game. Or when you playing Madden! At home!

Ain't ran a down since Pop Warner & you talking
about the team like you on the roster!

Talking about "We"
gonna smash y'all next week.

Y'all got lucky this week, cause "We"
got some injured players.

You cos-play every season!
 Who own the league?

Oh. You mad!? You
quiet now! Where's your money go!?

Damn man let the people have fun.
Ol' Grinch ass!

For real for real,
You still mad 'cause Mom wouldn't buy

that Lion-O Sword of Omens joint for you
from Lionel Toy Warehouse back in the day!

Let them have some fun. Let them
be all happy and excited.

Let them
jump up and down like you be doing at in front of the TV.

Bruh #1:

I'm just sayin . . .

Storm Writes to Black Panther

T'Challa,
Remember when we fought our way
out of Hades together? This is what
those who truly love spend a lifetime
doing and we escaped. We saved
each other, and our embraces held
everything from the continent
that I missed. We were not mutants

or black or African, but distillation
of spirits. You could invent anything,
carry the legacy of generations borne
by your village, and fight the strongest
of the pantheon while some would have
us occupy the smallest storylines.

Forgetting has never been our option.
We carry our powers and our histories—
a colorline of veils, a rucksack without acres.
Tell me that wasn't enough to call us future.

Oya Invites Storm to Tea

If you are going to play me,
why don't you wear purple?
Blue eyes and washed out white
mane twisted about your head.

Seems like you had a tumble
due to a flutter of my hands.
The draft and tombstone seats
are not always comfortable
or inviting, but some people
feel the same way about me,
which is why I invited you,
distant daughter. Comic
book pretenses fail to do
your powers justice.

Summoning typhoons
and hailing rainstorms
are a flash of talents.
Dear girl, you can
change climates,
battle smoke
that hazes the sky,
sweep away toxins
seeping into the earth.

The dead whisper daily
prophecies, nudge me
to yank you
from Stan Lee's grip
to discover horizons
shifted simply
by raising your arms.

You can stop hurricanes,
start them, level houses,
raise water, ignite
anything in the open
urging of your palms.

You are change, clean
as the seasons and destruction.
The world will always need you.
Your eyes are not vacant.

I hope you like your tea hot
with steam and ginger root.
Sip deeply. You will need
all the strength that comics
cannot imagine.

If There Is Darkness

after the Dora Milaje

The women carry broadaxes, side by side
they come singing spear to spear
iron striking cottonwood, cotton humming back
the waters churn, the pump and shuttle
sweep the warp like waves against greenlit shores

They come from the heart of it, each stroke
covering the space between, from where they were torn
to where they trained together, to where they must go
the women in step see only the next woman's back
together they live the story—a story of blood
the rising tide of iron, slicing its way through flesh

If the sky's dark fabric is pierced by stars
they sing the songs of wombs, of the earth
giving birth to herself, of Herself giving birth
to earth. There among the green, twisting, fertile
things, they buzz with seeing, they blink back feeling
the wind and their weight of flat toes pressing into darkness
into the rhythms of the earth, they step, come, sing together
share the same breath, share the same death

The world is vast and wild and they travel
wary but with no fear, as they know none
have ever traveled alone in it, tethered first
to mothers, now they are tethered to themselves
to the sisterly beat pulse, pulsing in the next woman's heart
If there is darkness, they sing the light
They sing the songs of wombs

I of the Hurricane

(written on the only day in recorded history when two
hurricanes hit the Caribbean at the same time, 8/21/20)
after Grace Jones's "Hurricane" and Storm of X-Men

blame the sun for being inconsistent—
an unevenly warmed planet
crisscrossing between the Sahara and the cool
Gulf of Guinea shaped the bolts of my arms

the Taínos wrongly gendered me Huracán
unaware that this mother of destruction
wanted to lift the Atlantic into the skies
pre-emptively, stop the Passage
into an uncontrollable future only I could foretell

my waves splintered the early ships to pieces
my gales engulfed settlers by the shore
I cackled with thunderous glee when mountains
kissed my face in cahoots and shielded my Palenque progeny
but I couldn't stop time

so I turn the Earth apart
over and over again

every summer I raise electric lightning lanterns
hoping to see my children, raze palms
clearing the land and spinning the dirt East
sucking the air into a whirlpool meant to bring them back

some return, some stay
it's my pattern now—I cannot stop twisting
my hips in a hula hoop of heat and rain

I will always circle back to this place of sugar,
salt, coral, and blood, to cleanse
the land with I

Blade Speaks at Career Day

Out of respect for the no weapons sign posted
on the front door of Double File elementary,
I leave my sword, modified shotgun, and other
hidden essentials in the car. Today is for the children.

I walk into Ms. Bennett's third grade classroom
and quietly take a seat in the back row of desks.
Fred Thomas, a local carpenter, shows us how to bend
wood until it snaps. Says, You have to break them

to find their beauty. I remember wooden stakes
hurled at my chest. How skilled hands tried
to kill me. It's important to know what you're fighting
for especially when the enemy looks just like you.

The red-headed girl sitting across from me asks
if my fangs are real and if she can touch the scar
on my neck. This room of bright crayon and joy
is so different from what I remember of youth.

Ms. Bennett calls me up to the front of the class.
I share a complicated smile of sharp teeth.
One boy wets his pants, I say,
Basically, I'm an exterminator and I love my job.

Channeling the Energy, Borelson

Years ago, a pregnant woman was bitten by a vampire and turned.
Her son was born with the thirst but, being half human, he could walk
in sunlight unharmed. Though vampires secretly dominate the world,
he fights them—in part to prove his allegiance to humanity, in part to
avenge his forced isolation, being neither human, nor vampire. Because
of his deadly expertise and weapon of choice, they call him:

Blade, The Daywalker

Like a stake
in my heart: this life—

the seen,
the unseen—the ones

who look into the mirror
and find nothing

but innocence though they stand
in blood up to their knees.

You see them: shadows
not shadows, people who seem

to be people. You don't
believe me? I watch

their news, drink coffee
in their chains.

There's no place
they haven't touched:

it's almost like I can't
wake up, like I'm living

in a movie, a kind of dream:
action-packed thriller.

I never dreamed
this

hunger in my veins, this
mind that cannot sleep: why

do I whet this blade,
when they will not die

Blade, Historical

It is possible that God exists, but with everything
that has happened to us, could it possibly matter?
—Mario Vargas Llosa

You come into the world—
from where *from where*—
and the world turns

toward you, fangs bared,
disguised as what it is, as if
this is how it has to be:

as if it were normal to walk
the daylight knowing
something's wrong. *Grow up,*

they say, *get a job, go to church.*
And after awhile you stop
fighting it and try to smile.

Don't you ever wonder
whose blood is in
the banks? It's yours.

Follow the money
back to The Plague
and the rise of the papacy:

The Inquisition. *The Burning*
Times. The explorers
and the *explored.* So many

centuries, so much
death: you can still taste it
on the wind. Some days

I think, with the singing
of my blade, I can fix
everything—even the sadness

that says nothing that matters
will change. Some days
I think I should never have been.

Blade, Unplugged

It's true: I almost never
smile, but that doesn't mean

I'm not *in love*: my heart
is that black violin
played slowly. You know that

moment late in the solo
when the voice
is so pure you feel
the blood in it: the wound

between rage
and complete surrender. That's
where I'm smiling. You just
can't see it—the sound

bleeding perfectly
inside me. The first time
I killed a vampire I was

sad: I mean
we were almost
family.

But that's
so many lives
ago. I believe

in the cry that cuts
into the melody, the strings
calling back the forgotten world.

When I think of the madness
that has made me and the midnight
I walk inside—all day long:

when I think of that
one note that breaks
what's left of what's
human in me, man,

I love *everything.*

Praise for Luke Cage's Skin and Starshine

You know what it's like to be night
all the time, don't you? Others have
to wait for that artificial glow
via backlight or tanning booth. But you
are an element that can't be spliced,
 quantified. I like you bulletproof
and free, you make wanting to live
a life legal, where eyes can stay wide and
 hungry, not sad.

Everywhere you go black boys
follow, try to scoop the cells
 and selves left behind. Some have
tiny magnifying glasses and mini plastic
 cups. And when something is found,
they watch it like seeds ready to sprout
 wings or leaves of comic book power.
Others take their loot, rub it along their
hairline and edges like it's part pomade
 part starshine.

And I resist the urge to join the queue.
 Cause those light-skinned boys keep
their love too high for my skin's reach.
 Your Cage would have me moon rapt,
 wondering how a rooster moans,
and if my own father ever thought I
was beautiful. We'd walk through Harlem—
 you in a fitted suit, and me wearing
anything-I-damn-well-please, until
 rain or movie magic turns us
into one body, the right shade of
 Bernie Mac black.

Luke Cage Tells It Like It Is

Don't believe everything you read.
The exploits you find in my comic
are no more probable
than snow in Sunnyvale.
I'm not as black as you dream.

But a body has to make a living.
And I play the part
better than any. I know
the dangers of believing
every shade of black you see.

In this issue
there's a Mandingo of a man,
dark like olives,
voice as deep as a desert valley
in the dead of night. He smiles
as if he wants to bite your throat,
holds back his teeth
with those bubblegum lips
that he can't help but lick, leaving
the thinnest film of saliva
on the surface.
He's slick
and he's bold
and he's everything you imagine he should be.

Sometimes, you want to be him,
want to see yourself in the silver glean of his image
and other times you want to be wanted by him.
Crave his brand of desire,
his form of righteousness,
bringing a little black to the world
one *motherfucker* at a time.

No matter how three-dimensional he seems,
know that behind every *jive turkey* uttered
there is not a black mouth, but a white one,
one that dictates who he calls *Nigger*,
to temper the perfect tone of black.

This is the cruelest trick.
Even now, I'm defined by the borders
of my panels, the hue of sienna ink,
an assembly of lines, a rendering of man
splayed across your page.

BLACK ANTIHEROES

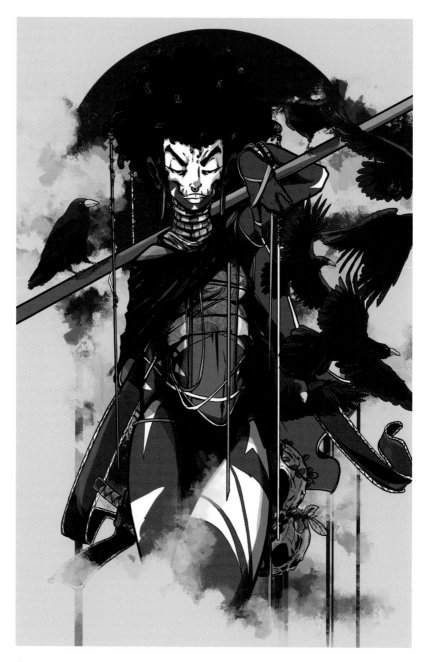

Raven, Wolly McNair

46

Eartha Kitt Reflects on Cat Woman

Some man always wanted to lay me down
but he never stayed to pick me up again
So I learned to make fear my friend
Made a temple of bone, my mind
hardback pews, regret the ceiling
of my skull. I scaled the night
my mouth full of the cathedral sky
I spoke in tongues, back arch
and leather shine
blood claw and tooth divine
I wrapped my tail around
the throat of desire
Many tried to hollow my spirit
usher their hungers into the bowl
of my brain, spilling their need
like blood-stained wine
against the fabric of my full altar
but I refused their offerings
Still, when the moon's shimmer
casts her spell over the city's
devilish light, I walk back
through the shadowed walls
of reverie, scrape and scratch
the old wounds and purr
just to hear myself remember
and bleed.

Ode to Lando Calrissian

If you were stuntin' in a galaxy far, far away, blue cape
suave, with a gold lining that would shame the sun
with a cool walk and a gambler hustle,

if you had a hair style so fresh, you'd claim
to have won it off an out-of-work cloud
city cosmetologist, if even your eyebrows

had scoundrel in their arch,
if everybody knew the music
bumped cargo hold to cockpit in the Millennium

Falcon, a name straight out of P. Funk,
if everyone could see those hands churning
the dark dream of stars into the buttermilk

of a hip brother running his own city
if we asked, *where are all the black people
in the galaxy?* Would you help us? Would you bet on us?

The Amanda Waller Suite

with respect to Nikky Finney

Episode 1: Amanda Waller Enters the War Room

She Condoleezas her way
through the Pentagon
with the stealth of a panther

visceral eyes peeled
mountainous shoulders arched
volcanic neck veined and

tongue triggered
to strike at the first site
of a five-star general

She's never fired a round
never donned a uniform
nor received gold or bronze

Let's call her black skin her badge
Her tight, neatly edged afro her rank
Her black heels the boots of war

It's not her impressive degrees
that pierce men's egos, not her
immaculate record of service under

several presidential administrations
that makes white men cower
It's not the armor of her power suits

that remains tough as rhino's flesh
Angelou said it's the stride of her step
She glides with the confidence of

ten thousand Valkyries in tow
The Negro spirituals would call her
a battle ax, a bulwark, a buckler

She stampedes this polygon not for love
Her countenance here will never endear
passion but fear, not desire but duty

She eclipses the dark room before aging
white men reluctantly standing to her
loathsome presence, daring not to trifle

with her ominous right hand of wrath
How terrible is her name in all the earth
that decorated warriors mask their terror

Episode 2: Amanda Waller Attracts a Bat

She awakes at 4:30 AM to click on
the 24-hour conservative news
and to scramble her attendants
into position outside her estate

The black suits with earpieces
prepare for her morning departure
All monitors are in place displaying
camera views at strategic angles

She has kept at bay an array of enemies
like viruses who lust for her execution
from shrewd international dealings
in the name of patriotism and power

yet she may well be T'Challa rising
in his palace before the dawn to witness
nighttime's daily silent defeat
But this imminent foe is the (K)Night himself

Undetectable by any lens
A vapor among shadows
Her intelligence, military science acumen
and bottomless war chest rival his own

In a stunning checkmate at their last encounter
she revealed to him that she knows his identity
prompting the billionaire in cape
and cowl to succumb to her flame

spiraling to the animal class of nocturnal
flying insect from nocturnal flying mammal
What could his privilege desire from her that he
could not righteously detect or ubiquitously procure

She cannot be intimidated by local police
brutality or a callous criminal justice system
She has overcome the plagues of
bone-grinding debt and ravaging poverty

from centuries of distributed wealth denied
to her people but hoarded by his with the same ruthless
injustice and sinister business practices he attempts
to thwart beyond his intimate obsession with the night

Perhaps it is this intrigue that brings him
to her doorstep to lust as her enemies do
To understand how she can excel in his
domain of chess-like maneuvers

on the world stage cloaked by
the same shadows he adored first
To investigate how she hides her deeds
of self-appointed justice in plain sight

within the belly and brain of the American
government's capital without masquerading in costume
while he chooses to toil endless hours in a cave amid
screeches of flying rodents who are

attracted to the shadows as he is
Now it is her darkness that lures him
to her grounds, her window
her sanctuary, her very shower

a glimpse of blackness in its rawest form
one weapon he cannot tuck into his utility belt
more darkness than he saw on his first night in the cave
but he is one with the night now and hers before the dawn

invading her turf
planting his flag
like any colonizer
to prove he can

Episode 3: Amanda Waller Has a Woman-to-Woman with Harley Quinn

She peers into a realm of the multiverse
and sees she is Quinn's mammy
donning the black and white maid uniform
with a toothy grin and fractured English
dialect of a broken education

watching her beloved Ms. Harley sneak back
through her bedroom window at night after necking
by the lake with Mister Jackson Napier
what to make of this youngin' who has
a life mapped out for her until death

Mammy worked her fingers to the bone all
her life so no time to marry
hell no time to make babies either
tending generations of white chillen
passing through the Quinn house

Who knew this chile would get touched in the head
Mammy peers through her own crack in the multiverse
to see Ms. Harley dressed like a schoolgirl who played
with her mama's makeup case and standing in front of her
is a familiar-looking, dark-skinned woman in a suit like a man

She looks mad at Ms. Harley who is sitting
in a chair like she's in trouble with the principal
The big-boned black woman in the suit with arms folded
does not seem impressed or threatened by the girl's whiteness
She doesn't have the luxury to date a psychopathic white man

She would have choked the maniacal laughter
out of him without a smirk of her own if he tried her
Joker only syringed Quinn's mind with his
hysteria because he knew she was malleable
She will not don a blonde lace front wig in pigtails

She lost a son, a daughter, and a husband
to the ruthless Chicago projects
She does not have time to lose her mind too
But as Mammy stares at this version of herself
she sure feels like she has lost every marble gawd gave her

Black women don't dress in no suits
and they sure don't look down on white folk
Mammy ain't got time for these games
so she goes to her room to pray to her
ever-loving gawd that these dreams from the devil

don't plague her sweet soul no more
yet while she sleeps she hears that shrill
devilish laughter cackling in her mind
with the high-pitch squeal of a blonde-haired
blue-eyed piglet following close behind

Episode 4: Amanda Waller Assembles a Suicide Squad

Her code name is The Wall
standing apart from other
man-made shields of wonder

To go rogue means to
assemble her own universe
without a gauntlet glove

within the government system
that rejected her kind and
now bends to her will

She has studied the masters
She breathes the same rarified air
as Harriet, Sojourner, Assata

She cannot be as open as Michelle
or Oprah nor need she be an assassin
like Foxy Brown or Sister Night

She is queen on this chessboard
Her moves are calculated
making the round earth flatter

Her foot soldiers have nothing to lose
They must follow her to their redemption
ready to go through a wall for her but never through her

Her code name means stone upon stone
If she falls on you, then you get crushed
If you fall on her, then you shatter into shards

If she calls your name, then you answer
or you will never see the sun through
her dried-cement veins or calcified-mortar bones

You do not possess the tools, the strength, or the faith
to break her down but if you negotiate your life
into her hands then she will open the heavens to you

brick by heartless brick

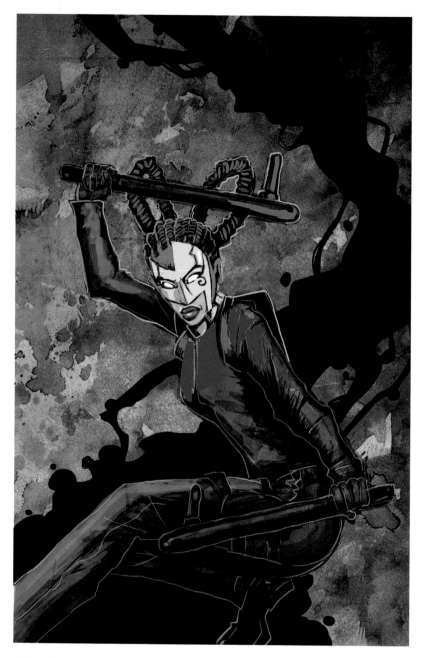

Ajala, John Jennings

Invocation

After the movie, I am one of many mouths
grappling with ashes, the way divine names now
knot when throats broach to conjure them.
And I know I should read this sunset as evil.
Should weigh the sabbath that Thanos
gouged with his ungodly rapture a sin,
an Iscariot guilt, a spear to the side of the
entire, vampirized sky. But I also know
what it is to be gnawed hollow, to haunt myself a
wreck of unmet musts, never
doing or being enough to prove those
ghost-choirs quiet. So Thanos sits and smiles,
and I wonder what I wouldn't also be willing to
dissolve if it meant a sunset un-
hounded by ruins, exorcised of every hope I've
shrined and then seen extinguished. These
stowaway poisons. How many good things will
eventually soot my fingers a lonelier peace?
Thanos swallows more stars than even Lucifer
tongued in his time—ash,
dusking the Serengeti kingless; ash,
whispering spores into a wound we again
aren't left the word for; ash,
wringing our failing reactors empty of
friendly, of neighborhood, of
something leaving us
cobwebs crying for footsteps—and I'm reminded
that this inferno I carry will burn
through everything I love
if I let it.

If I continue to pray at these altars,
the demands of past failures my
bloodthirsty god to appease. Because, like Thanos,
I too can snap myself a lessened sunset. When I
withdraw, when I give up on giving any
more of myself to the world, may Our
Martyrs of Crumpled Brass remind me of the ash
I am putting back in my throat. No life
but to recite myself anxiety's hymnal; depression's
bleak psalter, the only words still
allowed to burn. Because
letting defeat lead me to give up on living is
swearing off firelight because I fear the dark.
The dark will not smother me more kindly
just because I resign myself to it, to
starving for light if starving means never again
risking that light dying out; this
tyrant will always find a spark to swallow.
So, however it may tease the notion, a sunset
is not the answer. I would rather
bring these ghosts to daybreak, drag them into that
new fire like strigoi sentenced to sunup and let
their suggestions of ash combust before the light
that was always already mine. At least,
I say that now—my mouth still bitter with the cost
of Thanos keeping his commandment. My prayer
is that I will continue to choose this
thinnest of hopes when ash is no longer a
knot of stolen names but an invitation,
when it goes back to being a sky to
urn my silence under. If nothing else,
grieve me again. You throatache of a pantheon,
indulge me again with your disappearing bodies.
Hurt the titan's bargain farther from my hands.
Maybe the lesson will stick.

Elegy for Killmonger with
My Own Pain Entering Frame

Bury me in the ocean with my ancestors that jumped from the ships
because they knew death was better than bondage— yeah,

I heard about what you said, but nah. We both know I, the African
lost in America, had to come and claim your body. And to level
with you, homie, when I got word, no shock shot through me like
the lightning of revelation. I figured it was always going to end
this way for you, bruh; the child of pain is obviously pain as well,
couldn't dream of being anything more than its sorry daddy was.

Yo . . . my bad, E: I'm still really sorry about your pops.
He seemed—to me, even as a shorty—to be a solid man: present,
principled, dignified, almost like royalty dipped in black paint.

Part of me thinks he'd have made a decent king if a king was
something to believe in, which I don't believe it is, I mean, just
look at what kings did to the block, to the world. Hell, look
at what the idea of a throne did to you, your entire body printed
with the braille of insatiable ego and ambition; and rage, too—
what morphs us men like steroids do, turns the darkest of us,
the me's and the you's, into atom bombs without detonation clocks
erasing anybody within range of our hands or their hired guns.

At some point I feel we start losing track of whether the supremacy
does this to us or we do it to ourselves, but I've thought on it a bit,
and I've come to believe the truth has two faces: the one we hate
and the one we hate. I wonder which face flashed before your eyes
with the last kick of the war drum; if there's a God for gutter-folk,
hopefully, it was hers you saw—homegirl, forever down for you,
ride or die, loved the mess out of you, I thought. Hoped.

I said before I wasn't surprised, but that was only true until I saw her body wasn't here laying next to yours, y'all curled up together in power like quotation marks. I don't know if she got out or got in the middle of it, but I had a soft spot for her standing by yo buckwild ass even when you was on some absolute bull, when you should've behaved like you'd read a damn book in your life, and I know you read many cause I caught you once in second grade and clowned you all the way to MIT. My favorite book coming up was *The Autobiography of Malcolm X* cause it was supposed to be, you know? The half I finished, anyway. Remember that, homie?

Is that too far back? I can't recall when we last spoke, honestly. Maybe I've been dead too long myself, but I believe it's been just long enough for me to forgive you for it, enough to swoop you, take you to the other side of the sun where we can ball pick-up like that's all life is, like it used to be when we were misspelled boyz.

New Rules for Crime Fighting

In the Known World an itch will sound like
memory's alarm being triggered, and a rash,
a crime scene photo.

A mole won't be a mole but a receipt, for another body
taken under duress—against her will.

A new pore will open up somewhere on our skin
every time a bullet tells a lie—making a tiny bead
of sweat more like a tear.

When zimmermans remember
that the vessels that burst just under their skin
are simply metaphors for the river of blood
their ancestors have spilled,
hemorrhaging will be an effort to give the bodies back,
their seizures the only way to let souls through.

BLACK POP CULTURE

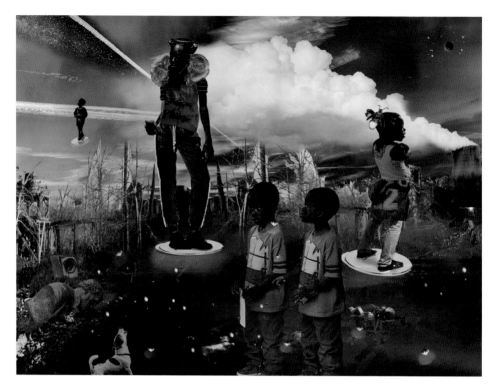

Southern Futurist over Civil War Soil, Najee Dorsey

the ending where queen and slim live

quite simply they fly think of
ribbons let loose into the wind
quiescent fluid unbiddable
like the way diana ross got swept up at the beginning
of the wiz on that quiet new york street away from
the memory of fear folded toto up in her arms—and
some part of her blood said *yes* to a hurricane
sweeping her up those killing winds bowing in
fealty to her so don't tell me
queen can't fly can't confront a quake of
unsteady bullets turn towards cuba trust the
weight of air sail on firmament root in black
salt hands outstretched in praise ears
ringing with mermaids' wails ride light
until she lands amidst a sea of black folk
holding on to the promise of free won't we
praise won't we sing won't we revel in the
fantastic we can birth

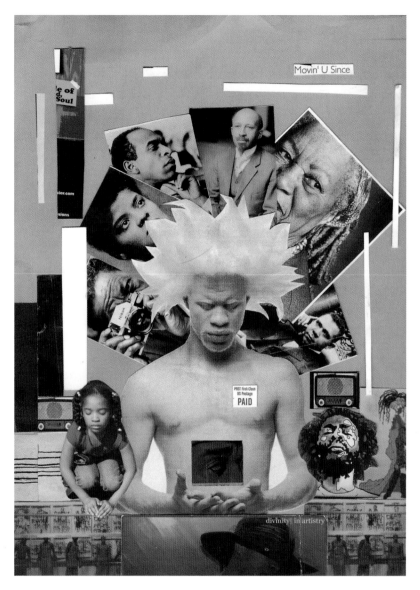

Stamp Paid, Derrick Weston Brown

So Jon Snow and Colin Kaepernick are in a pub . . .

and Jon Snow stomps up to the bar and demands a drink from the barkeep after his first meeting with Danaerys Targarean: *Mother of Dragons, The Unburnt, Khaleesi of the Great Grass Sea, Breaker of Chains, Protector of the Realm, Queen of the Meereen* and he's most vexed. He shakes his curly brown locks with an irritated flourish and vents to his surrounding entourage with a frustration only reserved for bastards and says, *I'm being refused resources, soldiers, all the things I need to possibly save my home, my people and the world because I won't bend the knee! Can you imagine it? All of this, over my kneecap touching the earth! Since when does fealty to a shuttered empire overshadow principle? Must it always be like this!?*

And from the back of the pub Colin Kaepernick, with an afro haloing his head like some ancient spherical crown answers, "You know nothing Jon Snow."

Let's Party in Space, Alice Kandolo

Before Sasha Lights a Bonfire

When my brother gets bitten
by a shell of boy, a gun molds
itself to my shoulder. Armor
shatters then crashes, sticks
to organs and weighs down
my feet. I still keep moving.
By the time I bury Tyrese,
I am used to digging.

I watched him cut through
hungry stumblers, rasps
and rotting gone silent
and fallen. Tyrese picked
flowers and cradled babies
in the trunks of his arms.

I knew if we both survived
every crumbling wall, each
collapsed fence, he and I
would look at each other
laugh and remember.
Instead I lose him, after
losing Bob and his jokes
to slow, rabid dementia
pressed from undead teeth.

Understand why I hunt
walkers, mow them down,
quiet relentless half-screams,
pile them in a pit then fall
on their finally still bodies.

Their decomposing
became a smell that
no longer phases me
while my back rests
on the huddled mess.

On my back, I look up
at clouds. Unbelievably
the whites still break
and float in clear blue.
Maybe, I can cry now,
maybe, for a minute.

To Lieutenant Nyota Uhura

Jet black curl whipped past her ear
to the rounded angle of cheek,
meticulous batwing eyeliner.
The red line sleek against
thigh, calves interrupted by
black boots,
but first, benediction.

In praise of communicator chirps,
in praise of the flashing monitors,
in praise of swirling chair that gave
of her sharp lashes and poised vista
of face, enough yet not enough.
Martin Luther King, another captain
of sorts, offered his gospel. She was
to be seen, rocketing toward future.

She is the vessel that carries and delivers
when she is navigator, guide, and seer.
She is the vessel that carries and delivers.
How often she is captain without title,
blamed as commander without privilege.

Question: Did the Vulcan ever ask you
how it feels like to be different?
He removed his pointy ears & brows daily,
ruffled his hair to normalcy, released his
anesthetizing grip. She takes off the wig,
but still wears herself, irreversible skin.

She becomes vessel that carries and delivers.
She serves as navigator, guide, and seer.
She is the vessel that carries and delivers.
How often she is captain without title,
commander without privilege.

The conversation that never happened:
I waited for you and Sulu to cast glances
like unwritten spells, give each other
silent nods, forge some way to defect
if aliens became allies. If the captain
barked too many times and forgot,
you were not just polished umber
to fantasize about in a later episode.
When you recall your surname means
Freedom, and Sulu Sea touches Asia,
when slavery and internment camps
failed to turn your ancestors to dust.

Uhura, 4th in command, a helmsman
never called Lieutenant, could direct
a story, steer the Starship Enterprise.

Sun Ra Speaks to Gucci Mane

Are
you guilty?
Bitch, I might be.
They said that you
said, to the white judge.
But I say WHY MUST YOU LIMIT
YOURSELF TO ONE SMALL BLACKNESS?
to a planet you have carved into the skin of your face.
You are ob-sessed with the cold, with the solid state
of water. Brrr the glint of your gold, but it ain't Horus, or even
the sand, it might be the record sk-k-kipping on the same dust speck
of what they call history. My story is the mystery but that don't mean
that I forget. When the judge looked me in the eye and said "I don't think
I've ever seen a nigger like you before." I looked at him and said **No,**
and you never will again. You see, my algorithm was born on Saturn with no mother
or father, like rhythm, the way Ornette say. I see the drum in the tree before the lightning *hit* it,
cuz my eyes wide open like the arms of Venus without Molly poppin, without slurring on a blunt
object aimed for the backa my head. Space don't have no trap spot 'cept black holes, maybe wormholes tore
through the velour of dimensions. I don't believe in violence at. all. Cuz that's not the way we do thangs in my orbit.
I woudn't fight Hitler, nevermind a soldier trying to express an appreciation for the joyful noise that I make.
Now your equation look a little bit more finite. But that don't mean you can't compose yourself into the cosmos' groove.
That don't mean that you need to be stuck on that old rusty gun clap, of what you call a woman when you think she can't hear,
or don't care. But why buy old sounds when you could shoot into the atmosphere raidiant, anew and get solar flare lit up?

Space Is the Place

in honor of Sun Ra

Calling planet earth
Calling planet earth

It's time we return to our cosmic altars
We've made the best of this earth

 Given it our music & acumen

P/Raised up ancestral wisdom
as we journeyed this terrain.
Danced in the jooks,

 in churches,

 in temples,

& discos.

 Genuflected our way after
 that mid-court shot
 where we sent the ball
 skyward like an Aztec prayer

Wielded pigments and clay
to finger, to figure, to fugue a future
of continual, contemplative,
and ancestral witness.

 Crisscrossed our way over

Atlantic foam and hydro-curl

 Carried the b(st)ones of our families

to the Americas
where we were auctioned
into the arms of Europe's greed

Seen by people settled in longhouses
whose visions predicted
such a horrific devouring.

But before that
we traveled
the space ways
where all celestial
beings dervished
their divine dances.

Our legacy is resistance
Our legacy is survival

& I mean to tell you that
 we are both here
 and out there
 at the same time.

"post-racial" as Samuel L. Jackson

You are an usher at MLK's funeral.
You are in a theatre in Chattanooga, Tennessee
 watching films edited for Black content.
You never see Sidney Poitier slap Yvonne De Carlo
 in *Band of Angels.*

You are a student at Morehouse
 during a protest taking hostage the board of trustees
You are suspended for some time.

You die in the first fifteen minutes.
You die in the second scene.
You survive but the brother behind you
 gets his head blown off
You have bits of brain in your afro for the rest of the film.

You are eaten by a velociraptor.
You are eaten by a shark.
You are eaten by the smoke
 of Gator's crack pipe.

 Inhale once
You're losing Isaiah.
 Inhale twice
You're showing Hallie how to hold it.
 Inhale a third time
You're Cannes Film Festival's Best Supporting Actor
 Nobody has won the award since.

You are trying to get a white reporter to say "nigger."
 He's got a great question about the "n-word"
 but doesn't feel comfortable with "nigger."
You dare him to say it.
You double dare him motherfucker.

Cause they think
You look like Laurence Fishburne.
Cause they call
You Mr. Glass.
Cause
You are Jedi High Council
Agent of S.H.E.I.L.D.
The highest grossing actor of all time

You die at the end of the movie
watching Robert Foster make out with Pam Grier.

You are the tyranny of evil men.

BLACK HISTORY

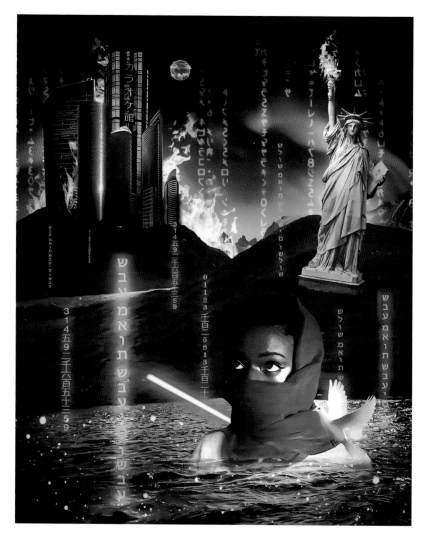

city upon a hill, Karo Duro

Joshua Bennett

Frederick Douglass Is Dead

& might very well remain that way,
 despite the best attempts
of our present overlord to resurrect

him without a single living
 black mother's permission.
If he should come, & be recognized

as anything other than the muted whisper
 of a body interred, I wish his return
as some strange & ungovernable terror,

a ghost story turned live & direct ectoplasm
 without warning: Frederick in the White
House kitchens, Frederick in the faucets,

Frederick posted up at every corner
 of the Oval office, shredding documents
invisibly, a blade in each of his eighteen

laser hands. *Go off,* his more radical undead
 colleagues will exclaim. *You better tell that man
to keep your name out his mouth.* But Frederick

Douglass doesn't say a thing. Not yet.
 He's waiting for you & me, my grandmother
says. Frederick Douglass is irrevocably dead,

& refuses to ride until we are ready. Until
 our prayers are knives or sheets of flame:
Hear us, O Beloved, Fugitive Saint: Defer

the rain. Grant us the strength of a rage
 we can barely fathom. Make us
brave as the flock in the fist

of a storm. Unmoor every melody
 they built from our screams. Steady
our dreams. Keep us warm.

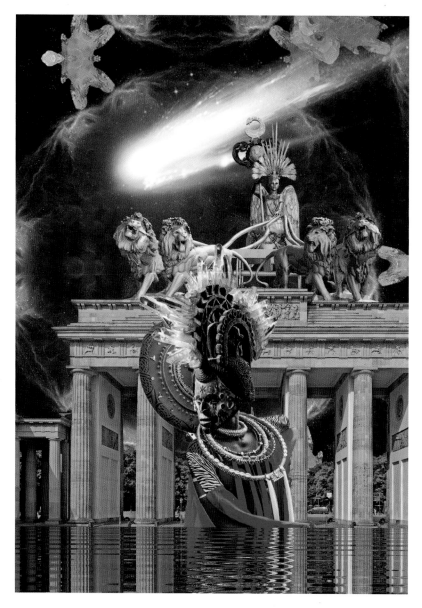

the new Queen's Gates, Quentin VerCetty

In Toni Morrison's Head

White girls die first.
Which means I'm still
alive, but breathless &
on the run in the brain's
maze of scrutiny. How
I stumble in the memory
of Ohio, old names & faces
given me: Pecola, Dorcas,
Violet, Nel, First Corinthians.
Reinvention is my birthright.
With each step I am altered:
mother, daughter, river, sun. A tree
swells on my dark back
& no one waits in the future to
kiss me, only the towns-
women hissing at my
inappropriate dress, but not
at the sweet-talking rogue
who travels with me.
Inside the mire my heart
still pulses at first, fatigued
& deathbound, then quick.
There's not enough milk
for all these babies or
the blue-eyed dolls yanking
their mouths open & shut.
Give a little clap, clap, clap,
chant the children & there's some-
thing ancient about the music's call
to order. *(Put them in your lap.)*
Who wouldn't stop to trace
the scars on the walls, their

embroidery of skin, stitches
that stretch for miles? *Not I,*
says the Jolly Old Woman
disappearing in a warm tunnel,
asking, *Toni, won't you tell me*
a funny story? I cut my losses
& sprint. I'm smoke, I'm ash,
Holy Ghost & Crucifix,
the preacher reborn to a body
in the grass, chirping, *Death*
is so much different than I imagined.

uncanny emmett till

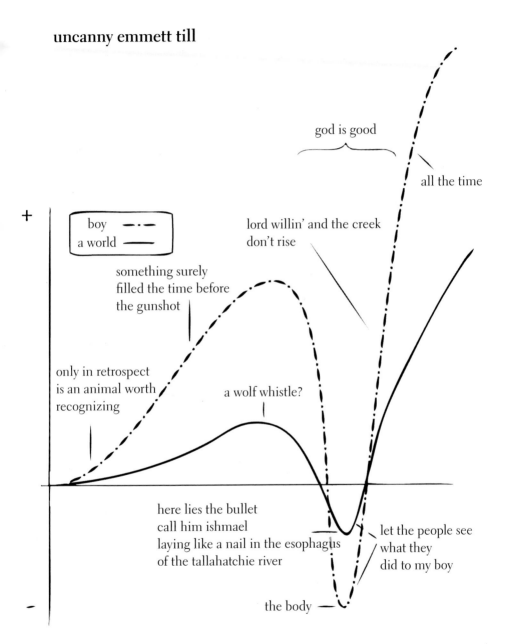

+

god is good

all the time

boy — · —
a world ——

lord willin' and the creek
don't rise

something surely
filled the time before
the gunshot

only in retrospect
is an animal worth
recognizing

a wolf whistle?

here lies the bullet
call him ishmael
laying like a nail in the esophagus
of the tallahatchie river

let the people see
what they
did to my boy

the body —

−

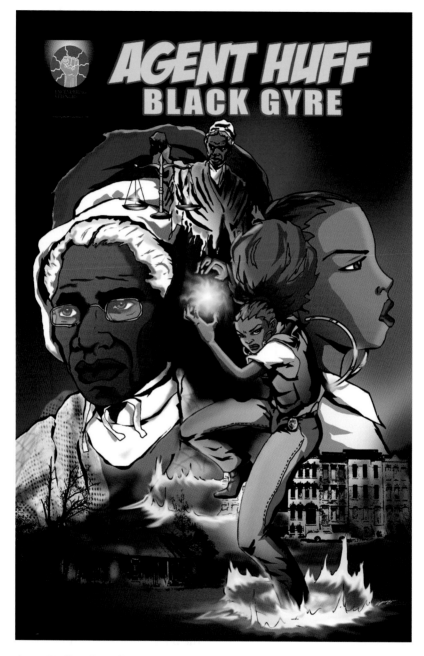

Agent Huff, Yorli Huff

Soul Power / James Brown Time Loop

everything is color and sweat, like the pinwheel that marks
a time jump on *justice league* or *wonder twins* or *batman
& robin*. it's all spinning to the tune of those horns in
"soul power" by james brown, who was, i think, some kind
of superman, because he wore a cape / because he could
see through you to the whitemeat / because his heart was
wrapped in a blanket of green glowing money, faster than a
speeding bullet, funkier than george clinton stewing in a vat
of radioactive gym socks, he was the originator of a time
loop, of a horns section that would not (could not) quit, of
a bridge that led nowhere but from one side of his growl-
ing throat to the dark loud other, and it's here, in this time
loop, in this trumpeted commercial break, that i see just how
caught up i really am—

—the man i did not love is sitting at my dining room table, gobbling up a
cake i baked for his unremarkable birthday, and in the spitshine of his teeth,
emerges the metal-shining smile of the other man i did not love, who did
not love me, gobbling up the edits i made, painstakingly, on his poems,
and in the ink, black and boogeying on the page, rose the whiskers of the
other man i did not love, framing his slow and drawling mouth, his words
slipping, thick, out of his lips, and then they were all the same man, in an
endless, spinning, trumpet-filled infinity in which, yes, i could get on down
down down down down, but not out. every wall a new man dancing a two
step to a tune that will end in my demise—

—and james is telling me how i got ta got ta feel it, and
maybe he's right. this is the funkiest hurt but it got to hurt,
it got to, james said so, cause when it's finally over, when the
trumpets quiet down, my body still knows how to dance
all over the beat still pounding in my heart, how to recog-
nize these unrelenting sounds, these men making dissonant
music, how to turn that hard hurt beat into my own sure
feet stomping it into beauty.

Octavius V. Catto

Philadelphia 1871, 2017

Does Branly Cadet's statue
capture the moment when Catto
was shot pointblank in the back
at Ninth & South for
having the audacity to
talk back & push for jobs, voting rights,
and being a Pythians baseball
star on a diamond in the city

or the instant when, almost
like an angel wearing sturdy boots,
Catto spreads his arms, rises
on one toe, & ascends
welcoming us into the new
history of the would-be nation
he fought for and brought

(tried his damnedest to bring)

into being?

(((in my marvin gaye voice))) light year(s) / ahead

u & dis ■
gon be gettin down

on a bench under a gazebo in a park on de equator of
neptune wif real firearms spread all about us / amongst
a picnic basket fulla starfish expresso & stickie-ickie / &
wif no police to white-light us into anything afterward(s)
we gonna bathe each other earlobe(s) in pryor & moms
mabley joke(s) as we munch on tuna nigari tween sip(s)
of bulleit / real aberrant negroid shit / u gonna call me
dammit muddafukka sr. when i saturday yo
eyeball(s) blkless / *la-di-dadi* jus(t) gon come gigglin outta
u under an elderberry moon inside a turmeric sky wrap(d)
roun(d) dis new city of jericho / u & dis ■ gonna be gettin
down after de dance

friday (2020) – poem

on de anniversary of de march on washington & emmett till's murder
baba franklin transition(s) while martha moan(s)

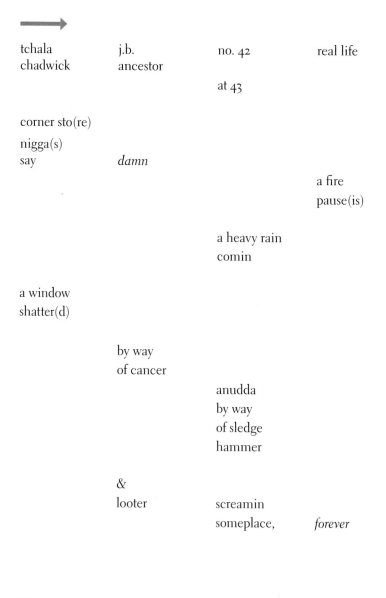

tchala	j.b.	no. 42	real life
chadwick	ancestor		
		at 43	

corner sto(re)

nigga(s)

say *damn*

 a fire

 pause(is)

 a heavy rain

 comin

a window

shatter(d)

 by way

 of cancer

 anudda

 by way

 of sledge

 hammer

 &

 looter screamin

 someplace, *forever*

Harlem [3]

The unfortunate news
for Langston Hughes
is that Harlem feels less like jazz
and more like the blues
This gentrified hood
being drained of its color
is like going home
and finding someone has replaced your mother
Harlem
Sunday afternoon ghost town
where the street names are the last proof
that New York's glory was brown

When Thy King Was a Boy

with thanks to Ed Roberson

The most recent headline on the Dead
 -spin front page reads *LeBron James*

is omnipotent & the first thing
 I think is that even back in 2006,

his advent means a certain kind of undeniable,
 post-soul apocalypse. The man

was low-key Copernicus
 in this sense, at least for all those boys

at the baseline of my memory's best
 eye, coming of age in M.J.'s wake,

wandering wild with no martyr
 to call archetype, no popular afterlife

through which to measure the value
 of a solitary human breath. We were 16

on the bench, starving for exits
 our bodies might build from hours spent

in tepid gyms & backs of buses
 scanning Faulkner, hedging our bets

with the books in case Cornell never called
 on the ball front, & we were forced to let go

of dreams already long-destroyed
 by genes & childhood vice. All that untapped

fleshly potential, sacrificed
 in the name of first-person shooters,

chess lessons, friends who fled
 when beat-downs swelled beyond

their means. But Bron would never
 do us like that. This we knew from his high

-definition entry into the land
 of the generally despised & perpetually syndicated,

only a year or so older than us but boundless
 in his vision & grace, vicious with the first step,

every outlet pass launching across
 the length of the court as if cannoned,

or indwelt by a god of pitch,
 summer waging its two-front war

on our hair & skin & no one
 cares to breathe. The boy king

rises like an aria. We sing.
 He, who will one day

carry entire economies
 in his stead, but for now

is little more than a hunter
 green headband, honey

-colored 23 emblazoned
 across his chest like the chosen

few of us back then
 with the game or gall

to claim that we too
 had inherited the air.

VIDEO GAMES & FANTASY

Woman of sand and stone, Karo Duro

ode to pokemon trainer Red

(B) has always taught me to run whether it be from a pokemon battle or
an unexpected visit from an actual bee's noise.
i *(B)* run up stairs

like i'm sure to see my father. & i am not his, just mine, & my thick hair
twists, once in, now, just now, an unrivalled out. i barely
care about what he thinks about my hair,

the ones i love, the way i dress, the way i give love, as i would barely,
remember my nintendo DS Lite. how it don't work no more 'cause it had
guillotined to divorce right after the charger had broke.
i do remember
 Ranger, & Platinum, & Diamond, riddled quiet in dusted cases; each
pokemon game & cartridge i
had as all i had
 when
my father wasn't there. & when my son, *Mew,* reached level 100, i had
made the best of the hand *Oak* dealt me. *Red, Ash, &*
Silver
 all dreamt my dream for a father & i remember how they all never
spoke. & i
remember whichever name you gave him

becoming the boy's name. Silver's mom got running shoes from Silver's
dad.
Silver once bumped into a cave atop a mountain
 & then found him - Red,
 at its precipice,
 transforming into,
 now, just now, a Mew

- with its hair returned untethered & to
 its original form; & so mindful
a Mew, in fact, he did learn how to learn any move so one

might be performed like a dance which might serve, like a mating call, to summon
 a father who too searches for father.

remember? that conflict with Mew. once led ash's heart to petrified stone in the stale air. & how diamond should sublimate to stale air,
a Pikachu's tear once hauled Ash from his cryogenesis, in fact, so well - Ash hasn't aged since, which implies Ash could die & get born again & still have no father. we all remember

waking up alone & to a new mother, saying
 not a thing
 has changed, *not our father,* *not*
our mountains, *not Pokemon.*
 as fathers go unmentioned in the games
 until 2002, my dad & i still don't talk.
i wonder about how much it has to do with

being a father. i go to capture
a moment's truth & stick it in poems
as trainers *(B)* run to catch the Mewtwo
 with just pokeballs.
i hope Red had taken time to write his
requiem for his lost dad, when trainer
Silver, had happened
to find him praying at the mountain froth.

perhaps Red caught a cold & this
father-poem needed to be about how cold & alone Red felt. maybe his throat
hurt too much to talk so Red fled the fight
 in hopes to get a healing with
his father. maybe it was less of a *(B)* run & moreso *(A)* jump; that his father was just
a sky away. just now.
 i *(B)* run up stairs like i will
see my own. in the sky. from the top step of mountains until i'm
downstairs with my single mother again.

God Usopp

I lie to space and time,
make movement my minion
my pockets are infinite with tricks
I explode suns from my hands
as if my body was a universe,
swish liquid pepper juice like
mouth rinse and breath gas rings,
release mustard seeds like scattered
showers, I have an army, if you believe
me.

I can lift any planet
if I write its name on a smaller
object, say I will soon draw
a sword and bring out
a leaky pen, an organ
bloodied with tales of
a hero I want to be.

Until then I
am a pencil sketch,
can shapeshift
into however greatness is drawn,
easily erased next to my comrades
who don't share my shade
or nose, which is so big they think
I am a lie from head to toe.

But I too have a talent,
I know how to make
a reach, may it be
a story, or my slingshot's string.

Majora's Mask

Alone, it speaks to me.
Do you want to be
Successful? Do you
Want your mother
To be able to pay her bills?
Do you want to go back
Home?

You don't want to go back home.

I don't want to go back home.
The strap behind the mask is invisible
if worn long enough, I forget my original
face. I laugh at jokes about my grandmother's
slow draw and post slavery tongue.

It is easier to get to where I have to
go, to not return to
being swallowed. It is
to taste the throat of the
oppressor before they hurl
a racial slur forward.

The only way to survive
is to be something else. Before
a meeting, a job interview, I
never forget to put on
the mask. I trace the inside
of its figure, it dips in and is
wooden like a coffin. I struggle
to put it on sometimes, it is a shell,

I hear the screams of those
who wore it before.
My ancestors.

Ode to Pinky and the Brain

with electrodes taped to their skull,
drowning in a beaker of distilled water
on newly FDA approved drugs, outside
of a table of scalpels and autopsy knives
to test the effects of opiates or antidepressants.

They wake up every day
to say we will do what we always do:
take over the world and not
evade certain death or not ask
how will we die today
brain?

Black Magic Is Only Bad in the Movies, Wolly McNair

Keep De Hacksaw on Mary Poppins's Throat

We got sum blkening up to do
w dese kiss-mey-ass fairytales.
Nah-nah-nah, Anansi say:

>> Likkle Miss Muffet does watch too much
>> Love + HipHop, she alwys ready to fight.
>>> Tht ol' wmn in she shoe, bwoy,
>>> she pickney crazy fah so.

Likkle Bwoy Blue is ah calypsonian frm Point Fortin.
Papa Bois slit Peter Pan neck fah pissin in he garden.
Motha Goose get cook fah limbin' in ah pot ah hot water
down by de barracks.

>> Baa Baa Blk Sheep, Anansi + de Laventille bwoys
>>> thief ah golden egg frm under IMF fowl
>>> fuck Kentucky Fried Capitalism.

De three likkle pigs + red riding hood
bring ah class action lawsuit to de wolves' ah Wall St.
Dey catchin charge fah brkg + entrg, destruction of property,
plus, granny hit thm w identity fraud.

>> Weee papa' is bachannal by Heaven's gate.
>> Douen' follow de piped piper down to de river,
>>> how many white ppl tears drown dey baby,
>> but not befr blamin' blk ppl fah theifin' dey chil'?

Whn Georgie Porgie pudding + pie, kiss de gurls +
made thm single motha nurseries. Too many grown up
fairytales end in Jack De Ripper type allegories.

>> Hear nah, even de matchstick gal tell meh,
>> dis world cold cold cold lik cockroach get catch in ya fridge.
>> We is all one paychk away frm selling we last candle
to de blasted snow.

GRAND THEFT AUTO III (2001)

My guns are loaded with imaginary numbers:
the people I kill don't count against the city's reputation,
the people I rob have the money again tomorrow. And
I'll take it then, too, because it feels good to *can*
for once or however many times I leave the hospital
with another life to live on the wrong side of the law.

> *Strategy guide: be a pacifist inside*
> *the shell of a violent person.*

I want good credit to my name to have the space
to sin. OBEY is the name of my personal brand, button-
mashing my way to academic excellence in geometry
while I bash in a black face with a baseball bat, a face
replicating at random in a restricted area of binary code.

> *Strategy guide: bad things aren't bad*
> *if you wear a white man to do them.*

I bribe a mini-skirt into the back seat of a stolen sports car
and watch it rump shake on its axies; with my silent, black
face I ask a classmate to leave me the "frick" alone.

> *Strategy guide: your default is "scary,"*
> *so be smart about when you smile.*

For my crimes, I take my punishment quietly, mean mug
mug shots Monday through Friday, as a singular form
in a room full of plurals. Then I come home, boot up, turn
up the volume high so I can hear the time bomb's
explosion mark my mission complete, let my mouth
burst into pixels of pidgin, then peel out, peel off
my face, and the one under that, and the one under that,
until I get tired of playing a game I can never beat.

from Over Deluxe AF

Emancipation's not its *raison* for raising.
Better I see by C. Smith's[1] lit shade.
I'm calling up Cauleen for to say AfroFuturism
does what it does when how what it does it with
is how it stay doing what it be doing
without only doing what it's done been doing.[2]
Mmmm.
Mashing "Dirty Computer Love" through Bluestooth,
flying's not always away, but sometimes a ways over
for a cool lick of fresh Black sky.
From up here, I may happen to hear: some dooms
don't favor my flavor.
I may look down there: those pretty, pretty lights.

1. Cauleen Smith, interdisciplinary filmmaker and Human 3.0
2. Or: "technology, movement, and reinvention" by way of Tisa Bryant, see "The Syncretic Hinge," Lana Turner No. 11.

Maroon AF

But Black, It Can't—

NEW ORIGINS

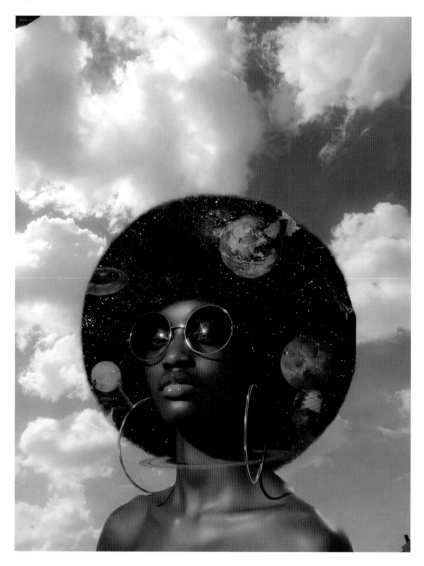

Galaxy Woman, Alice Kandolo

Jim Crow's Dirge

—*after Mark Antony*

niggas brothas sistas
 from other mothas

 lend me your ears the evil gods

do live on the backs of men tonight

 we spill cognac on the dead— booze over
drum beats no shoes

let me say:

i do believe y'all is honorable men i do believe

 y'all understand i come to bury this

 watermelon you see

not to raise it i do though praise them

Igbo usurped that slave ship

 over near Georgia

made the white men jump right from the bow

i done seen a house fly

from the fight cloud of smoke

muskets' muzzle burning crosses— i be done seen about
everything after that

 Fat Crow say

them Igbo washed up in Saint Simons then the slavers
come

for their dough the Igbo man

they walked into the swamp they went by
choice

Glasses Straw Hat

Preacher Fat

we felt the cypress sigh let us go

 the Igbo flew that way

money in the wind

that kind of freedom

 kind that let's me whistle at every woman i see
white

 let's me shake

my stanky leg in church and at festivals

 and birthday parties bear with me y'all

my heart in the cotton field my coffin
the shimmying ghetto

i ain't shivering inside

 police search lights crack

pavement eye of chimera
the way it comes down on you—

that white

after the club

when the ground surrenders
 Hennessey

then comes the wave

all there is
 this here world— all there is—

 sun flaring
they walked into the swamp

they went by choice

 burning effigies

 belly full of spinner kibbles

start drinking when the bodies wash up rain from the sky

until the water is sable

 until the water is uh— that feathered wave we

 climb over our dead during

 the break friends dig your beak

 into the present and don't let
go
 don't go

too far out in raw waters

 the wave so big

ain't yo story to tell but y'all honorable

men y'all swallow your expectations like the skull

 of a week-old fox or eagle egg—

 stuck in the throat

 arrested

How to Become Your Own Supershero

Facing death
I know that there is more to life
than what we all can see.
In the ethers
I hold onto invisible threads
of what mama and grandma passed down:
golden and silver cords of hope, courage and faith.

With Multiple Myeloma
I have lost more than the 20-year-old locks
that hung down my back.
I have lost my hand and heart:
extended for twenty-seven years
taking poetry to students
across the country
across the world.

I lost the music in my smooth stroll.
I have not danced for 10 months.
I lost my breath—
the capacity of my lungs
punished by pneumonia twice.

I lost my hair,
my bald head gets look: outright stares.
People cannot hide their questions
or hide the horror
scrawled on their faces.

My self-portrait is Frida Kahlo-esque painting,
my illness turns me inside out
paints both the seen and unseen.
I am surreal.
I am lesions on skull, clavicle and femur.

I am cracked bone and marrow siphoned
I am weekly blood draws.

I have had to hold my own hand
to save my own life—
2.5 million stem cells needed
I summoned 12.5 million, a record.
Don't believe them when they say,
"This procedure will not hurt."

I am High Dose Chemotherapy.
If the cure cancer does not kill me, I'll heal.
The shadows on my face
are maps of where I have walked,
landings without light.

53 days later, I am lighter,
a shape shifter on this path
I did not choose.
Yet, between the veils
I morph into this dreamlike mist.
I feel like both an angel/ancestor already.
Time is surreal.
I am glad to escape death this go 'round,
but I saw the grim reaper twice—
his scythe ready to level me.
I have come through this cancerous fire,
finished in the kiln at the highest heat,
a hard-won beauty lit from within.
I duck and dodge and summon strength as:
Wakanda Warrior Masaai Woman Southern Sage.
I meet the looks I get with a direct gaze.
Stare translated: If cancer couldn't kill me, you sho can't.

The Book of Mycah

Son of Man. Son of Marvin & Tallulah. Son of Flatbush & roti &
dollar vans bolting down the avenue after six. The boy grew like a debt,
& beautified every meter of the pock-marked, jet black asphalt which
held him aloft on days he sped from much larger men along its skin.
Godfathers & hustlers, Division 1 scholarship forfeiters, alchemists,
liars, lasagna connoisseurs, Internet mixtape DJs & baby mama conflict
consultants, each one appearing as if from the smoke of our collective
imagination, Jordans laced, drawstrings taut, all of them gathered one
by one to race the gangly, mop-top prodigy from the front of Superior
Market to the block's endarkened terminus, the same corner where Man
Man got jumped so bad at the back end of last summer, neighborhood
residents came to regard the place as a kind of memorial & it was like
this every other afternoon, you know, from June through the final days
leading up to the book drives & raucous cookouts which signaled our
school year's inauspicious return, this was the manner by which Mycah
Dudley first gained his fame, dusting grown men without so much as
the faintest scintillation of sweat to make the performance ethical. It was
damn near unsportsmanlike, his effortlessness, mass cruelty in a New
York City dreamscape, the laughter of girls with hip-length, straight-back
braids & baby powder Forces making every contest an event worth leaving
the perch of your bunk bed, stepping out into the record-breaking swelter
that summer held like a trap door for kids with broken box fans & no
mother home for at least four more hours to fill the quiet with discipline.

<div align="center">:::</div>

We gathered in swarms to gawk at our boy before takeoff. His flesh
maroon-clad from head to foot like an homage to blood, black plastic
afro pick with a fist for a handle jutting from the left side of his high top
fade, his high top Chuck Taylors, size 12, sounding like ox hooves once he
entered the groove of a good run & the distinction was basically moot at
that point is what I am saying, the line between him & any other mystical
creature, any worthwhile myth, any god of prey or waning life.

:::

The entire block was out that night. Firecrackers packed the blackening air, their fury matched only by the exorbitance of dope boy convertibles turned mobile dancehalls by the moment's weight. Which might explain why no one quite remembers when, or how, the now-infamous brawl began. Only that Mycah was in rare form earlier that evening, having just embarrassed Mars Patterson—so named, it bears mentioning, for the chocolate bars he loved to steal & trade on the 4 train, not the red rock planet or lord of war—but was now in his everyday mode, seated on the stoop, a seer with so few words for devotees & passersby, each eventually stopped asking for his backstory, for his praise or functional wisdom, & instead were content to let him eat his veggie patty with cheese without interruption, which he did, which he was, when the din that always accompanies someone's son's public pummeling rang out, cut through our scene lengthwise, compelled the boy, for the first time on record, to leap from the steps of the brownstone his nana died braiding hair inside of, enter the scrum, thresh the crowd for signs of the conflict's center.

:::

General consensus has it he was looking for his little cousin, & found him, even before the initial cop car ran like a living ram through the people. Before the boys in blue sprang, a spray of navy flechettes, from behind its doors. Before they were caught in the scuffle, released 10 to 20 rounds of ammo into the crowd without warning, bullets glancing off of Cutlass doors & corner store glass built for battle, all but three or four of which entered the boy mid-stride, lifted his six-foot frame from the ground, legs still pumping. For a second, you would almost swear he was running *through* the gunfire, preparing for liftoff or something, little cousin held firmly in his arms, shielded from the onslaught. *They never would have caught him if he hadn't been holding that child,* said no one, though we all thought it during the weeks following that moment we each froze, the moment his body collapsed slow as petals upon the unremarkable cement, & we stared at our champion felled by an outcome so common we don't even have a special name for it. Still. No one standing ran that day. Most of us turned to face his killers, hands at our sides, determined to make them make it a massacre. But all that was before we heard Man Man let off a scream so full it rent the crowd in

two, split the circle we had built around the boy's corpse, our human wall parting to watch each casing fall from Mycah's still-wet, dark red sweatshirt onto the street. Hear me. I heard the gunman's greeting. Saw hollow points etch apertures into the boy's clothes. They shot Mycah Dudley, quite legally. He died that night. He rose.

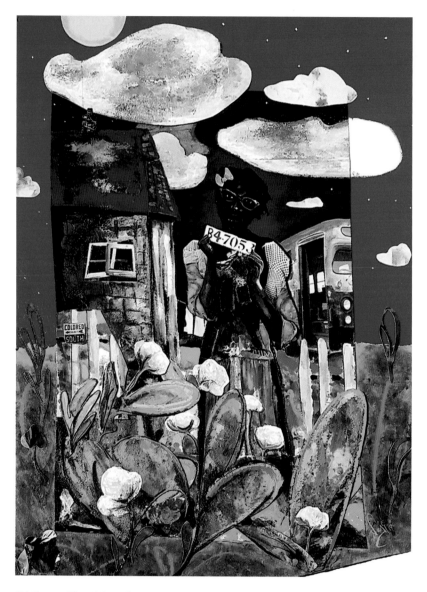

B4-Rosa—Here I Stand, Najee Dorsey

Origin Story

I want my powers to come in.
I thought, looking at my aunt on her death bed.
Heartbreak is my world disassembling.

Telekinesis, telepathy should blossom in
my brain; aren't mutant abilities trauma-fed?
I want my powers to come in.

I could chase out the cancer that wants to break in.
I could mold rage into racist-piercing lead.
It will be no heartbreak, *their* world disassembling.

Ignorance is so often lobbed at my dark skin.
Enduring mediocre White men deserves a godhead.
I said, I want my powers to come in.

Stretch soup, balance books, what can't a Black woman mend?
With powers I could resurrect armies of murdered Black dead.
Damn all this heartbreak, this world's disassembling.

Class 5 mutant powers, I'm ready to lean in
(I've stood over too many deathbeds.)
I want my powers to come in.
See this heartbreak? This world's disassembling.

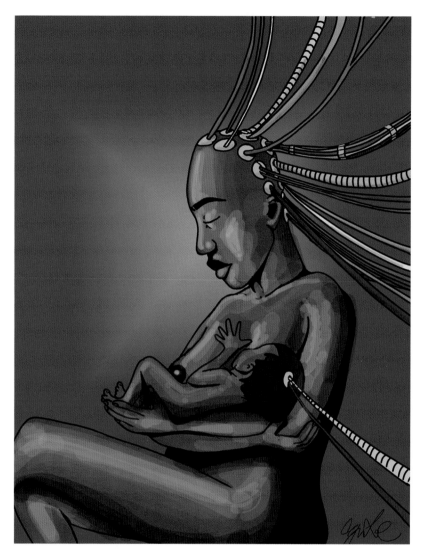

Generations, Cagen Luse

Five Chanclas of Death

Grandma used her chanclas like nunchucks. She had a hair on her chinny chin chin that coiled and stretched on command. If you ever sucked your teeth under your breath, huffing and puffing a side-eye, she'd whirl and whip it on you like the switch from a tree and light your ass up as you tried to make it out the door. She wore a bata all the time and everywhere like a second skin, with pockets that could hold *The New Gideon's Bible*, a rolling pin the size of a Louisville baseball bat, *The National Enquirer*, Bambu paper, a *TV Guide*, a remote control replete with corroded Double A battery acid crusted over the buttons, day-old Italian bread for the dirty pigeons she pinged unwittingly outside our window during feeding time, a paperback copy of Erica Jong's *Fear of Flying*, and an extra pair of brown chanclas smuggled from a Woolworth's on Fordham Road in the Boogie Down Bronx the summer the city had a garbage strike and the Son of Sam was running around like a sweaty dumpy Cyclops clod sneak-killing unsuspecting pedestrians and terrorizing New York City something fierce. If she had any more room in her pocket, she'd easily hoard sardine cans, Goya beans and Spam. No one ever asked her—and I don't know where the hell this came from—about her 8 1/2 x 11 inch framed newspaper cutout of Soupy Sales. One particular sticky night in the swampy South Bronx heat, just before the eleven o'clock news ended and *The Honeymooners* began, Grandma bounded down the rickety stairs of our Hunts Point five-floor walk-up in her worn-out chanclas and loose flowing tarpaulin-like bata heading for the subway with the determination of a pissed-off Pamplona bull. Alarmed, I shouted, *Grandma! Grandma! A dónde vas?* She shrugged me off and snapped, *Déjame!* When her chin hair started stretching and forming into a bastón—a rigid walking cane—holding up her Last of the Big Mamas weight, I knew where she was heading, but I left the crib without my asthma pump and all I could do between folding over like a table napkin trying to catch my breath saddled by my desperate intermittent wheezes was to manage to squeeze out another, *But, Grandma! No!* Without turning around, and flailing her floppy brown arms in the thick air, Grandma shouted back at me and a couple of winos huddle-praying to Jesus over

some Muscatel in a back alley, *Carajo! Hijo de Uncle Sam! I'm going to get that pinche cabrón sin vengüerza if it's the last thing I do!* For some freaking reason, and perhaps the heat brings out the freaks, a good number of criminals were on the make at the unfortunate time that Grandma charged into the subway bellowing, *Dónde estás? Dónde estás?* Her chin hair churned sensing the motion of criminal behavior. Her chinny chin chin senses settled on a motofreaky hunched over a nasty splintered subway bench with the words BIATCH and DONDI LIVES graffitied on it. The graffiti rose up off the bench like a mummy trying to grab at Grandma. But with lightning speed she beat it back with a chancla that came out of nowhere. Without skipping a beat or forgetting the horny Humpty Dumpty hunched over the bench, she maneuvered her triggered chin hair like a Taser, giving the vulgar pendejo a little jolt. Grandma called him a philistine. He jumped up crying, *Ay chihuahua!* As the startled girl ran off, Grandma lengthened her thickening chin hair, hurling it back and whipping the chump in rapid succession—*Whoo Ta-chich! Whoo Ta-chich!*—followed by his—*Ay Ay-Ay! Ay Ay-Ay!*—clutching at his stinging glutes. Before he could make it up the stairs, Grandma reached into her pocket with the entire hoarder's catalogue clusterfuck and log-jammed with so much junk. Cramming her hand through the clunky morass, Grandma managed, without looking mind you, to produce a brand spanking new chancla with the price tag still dangling off it. As if a knife thrower, Grandma dinged the would-be rapist in the back of the head, paralyzing him as he dizzily waved at stars twirling just above his head. His drunk cockeyed self could not make heads or tails of the knot forming on his forehead like a woody. Grandma turned to me pointing with her lips—*Mira! Cheech and Chong*—at another suspect dude nodding into a serious Weeble Wobble lean-to, his face nearly scraping the gum-spackled platform, miraculously never touching the grimy ground. But then his stomach rumbled so loud we thought it was the downtown 6 train roaring into the station like a tornado or the Tasmanian Devil. It turned out to be a volcano of churras formulating like dark brown lava from his dingy-ass white Polyester pants from Easters gone by. *Ay fo!* Grandma yelled, her chin hair twitching and turning at the sudden choking fumes. The weight and violent heat and pestilence of the churras caused the tecato to tilt, jerk and tumble over the platform heading for the tracks to a deeper Dante's hell down below. As rats the size of polo ponies scrambled off, his dripping candle wax face torpedoed its way toward the train tracks. But before his forehead, nose and chin smacked into the third rail, Grandma

knocked off two fat hobby horse rats with one boomeranging chancla hurl while her chin hair sprang out like a lightning cable, snapping its tentacle around his neck and yanking him up and out with such ferocity he didn't know what hit him. Grandma plopped Cheech and Chong onto a bench as his comatose high never skipped a beat, save for when he managed to lift his head and open his eyes to mumble through heroin drool, *Hey, man . . .* before he continued his deep space nod. Grandma turned to me, five vomit green Lee Press-On nails clutched at a holstered, battered brown chancla, and said, *Mi'jo, promise me you'll never end up like this.* She produced a fatty from the pocket of her bottomless bata and asked if I wanted to hit the blunt she was choking on. *Nah, Grandma. I'm good.* We climbed up out of the subway toward the sun's light. Grandma limped on one chancla salvaged from the six she rolled out the crib with. The newsstand had fresh copies of the *Daily News* with that hijo de puta Son of Sam's can of Spam face on the cover with the headline: CAPTURED. Grandma shouted at the man at the newsstand as if he had anything to do with the headlines, *Oye! It should begin with CABRÓN, cabrón!*

The Original

This is the thing, there actually was a time
I could leap tall buildings in a single bound.
Even with these bony ashy-ass knees. That was
Before Brylcreem and Afro Sheen
Slicked my quaff back like a swim cap—*Woo Cha*—

Had me hurtling through hot air and ghetto
Sky like a pissed-off seal on the steal. But then
All that Black Disobedient Civil Rights
Mimmy Jimmy hit the set and my black arse hit them
Power lines so quick was no time to hold

Back these damn unruly curls—they uncoiled
From this invisible-ass Ralph Ellison durag
Like bedsprings on a porno set—or some clumsy
Cop trigger itch. Mugs caught me hanging
Midair between lines, cables and string—

This here froage caught up between laundry
Drying like stretched and quartered scarecrows
From fire escape to fire escape—with no
Escape—as if this shit was an extended
Metaphor catch-22 for my dumb dangling

Dizzy black ass. The red boots and cape
Didn't help none. Motherfuckers still
Clowned my ass sun up sun down until
I finally hanged it all up and the white
Boy—once again—got the job. And the

Rest, as they say, is his story.

Shafro

Now that my afro's as big as Shaft's
I feel a little better about myself.
How it warms my bullet-head in Winter,

black halo, frizzy hat of hair.
Shaft knew what a crown his was,
an orb compared to the bush

on the woman sleeping next to him.
(There was always a woman
sleeping next to him. I keep thinking,

If I'd only talk to strangers . . .
grow a more perfect head of hair.)
His afro was a crown.

Bullet after barreling bullet,
fist-fights & car chases,
three movies & a brief TV series,

never one muffled strand,
never dampened by sweat—
I sweat in even the least heroic of situations.

I'm sure you won't believe this,
but if a policeman walks behind me, I tremble:
What would Shaft do? What would Shaft do?

Bits of my courage flake away like dandruff.
I'm sweating even as I tell you this,
I'm not cool,

I keep the real me tucked beneath a wig,
I'm a small American frog.
I grow beautiful as the theatre dims.

American Sonnet for My Past and Future Assassin

In a parallel world where all Dr. Who's
Are black, I'm the doctor who knows no god
Is more powerful than Time. In a parallel world
Where all the doctors who are black see cops
Box black boys in cop cars & caskets, I'm
The doctor who blacks out whenever he sees
A police box. In a parallel world where doctors
Who box cops in caskets cry doing their jobs,
I disappear inside a skull that's larger on the inside.
Question: if, in a parallel world where every Dr.
Who was black, you were the complex Time Lord,
When & where would you explore? My answer is,
A brother has to know how to time travel & doctor
Himself when a knee or shoe stalls against his neck.

I Imagine I Been Science Fiction Always

I've been queried about my nature and answered
I was the opposite

I was the objectionable object of manufacture

What I have been made to do I was made to

To a need—I am—myself—instrumental

To be played

Except—without effort for I'm laborious enough as I am my damn self

Which is to say that I play myself

Vernacular

Ha ha ha

Literal

Ha ha ha

Auto-thespian

Ha ha ha

"I is uh actor and never uh actor"

I agree it's complex—but my ITness demands it

Was I a simple machine—I'd have more leverage—more pull—I could screw with
their theirness better—I could make it plain

Their intention

But *complex* is what you call a euphemism

A lexical dustcloud

Complex as in I had me a *complex* about
 my nature being opposite

Complex as in their reasons for needing me
 to have an opposite nature are *complex*

Complex as in prison industrial—

Etcetera—etcetera

You could hide a whole mess of shit behind
a word like *complex*

My hide's complexion hides nothing

It's a shit show that the shit it show sure is shit
to them for sure

But listen here

I know that shit ain't natural

Which shit

Their shit

It's their shit that makes my nature be opposite

Opposite to what

Exactly—my dear Interlocutor

And if I am not natural because of their unnatural shit—then is that supernatural

To be both an object and a figment

I imagine I been science fiction always—
even though *they* came in the unidentified floating obscenities

That shit for sure wasn't natural

And I know from *natural* when I am seized by it

For sure—uncanny to consider those ships kin
or kith—but we are out the same factory

If I had to answer for my nature—call me batty—
but I'd figure like 50%

Like half the time—I have some nature to me

Like the blood in me seems too contingent to be blood

Like it's contextual

Which is to say—when it's on some hands it ain't never blood—but *shit*

Some category of shit

When it's under me—though—on the ground like some kind of shadow—it's blood

Or when it would be coming out me—blood—right then there

I don't even know if what any of them put on me is flesh

But I know it sure as shit isn't skin

speculative fiction: apocalypse

let's say the world doesn't end
and you go to its edge
and yes, it is a real place: the ocean pounding
and pounding at the gates, white foam
winged and salty and lonely sluicing
and feral will you
stay there, on your hands and knees
looking for god count your infinite
offenses into an unending rosary try to be good
on a land you never really
could claim kin to tilling your
lonely into a field

or will you find another way
make your own heaven know
the seed that makes you roam
this world like tina turner in mad max:
black bad assed and silver haired
enthroned in your own bare skin beguiled in
your own story its siren call

Derrick Weston Brown Sonsplains AfroFuturist/ Speculative Social Science to his Mother, a therapist who is also a longtime member of The National Association of Black Social Workers

. . . so yeah after posing my question about Therapists in Wakanda and, and, and if Wakandans even needed therapists on Facebook and, and then and then, after asking what an Afro-Futurist Therapist Speculative Social Science Practitioner would look like. I realized that most Black Therapists, Psychiatrists are Afrofuturists 'cause Boom! Helping black folks to save their black minds means looking toward the future vis-à-vis (did I use that right?) believing in surviving and thriving and building a black future.
Duh! Boy, where you been!?

NEW FAITH CONSTRUCTS

The oracle, Karo Duro

Black Jesus

Spain has the Black Madonna of Montserrat. Charleston South Carolina
has a Black Jesus painted on an old house at the crossroads that locals
call the Crosstown, also known as Highway 17. Black Jesus wears a red,
bulletproof suit and a blue cape. He's got a paintbrush and a can of paint.
The paint is rainbow striped, as is the brush. Looks like Black Jesus just
got finished painting the rainbow. Black Jesus has a dog—Black Wolf.
Black Wolf doesn't eat kibble. Black Wolf eats steak. The elders of the
city complain. Take that mural down; it's against the code. Black Jesus,
also known as Super J, says, No way. The city comes with a crane to pull
down the house. The house does not budge and Black Wolf chases the
crane away. Tractors come and Black Wolf chases the tractors away. Black
Jesus blesses the Crosstown, blesses the traffic. He leans his ladder against
a cloud. He paints an arc of words across the sky: Jesus is the only fire
escape, no more water but the fire next time. At night Black Wolf howls
at the moon and the moon goes away. Black Jesus has his fire escape to
glory. Has his red, Super-J bulletproof suit, has his blue cape, his dog.
Black Jesus can fly.

Toyin Salau, Khalif Thompson

A Better Savior

Negro

Don't you know
they only think Jesus
is white
cuz not enough of us
have died
for their sins
yet?

Imagine a religion, that changed history
just to be a better savior to themselves.
Christ
cotton/picking/woolly-head/manger/massah.
A re-envisioning of our saving grace.

We, the living residue of *Clotilda* 1859
Chained chauffeur of African Slaves

How do you murder your own Gawd?

Buoyant our blood
tar on the strangled feather
of a Bald Eagle.
Still dying
for someone
else's
sins.

Creation Myth

We brought them with us—the stars.
And we got here first.
We were navigators
looking to settle somewhere
that reminded us of home.
We were homesick.
That's all.
That's why we decided to stop.
That's why we stayed.
Don't listen
when they tell you, like them,
we slopped our way ashore,
dawdled our way
from amoebas to apes,
shedding vestigial limbs
along the way,
all mud-colored and oblivious
without the gift of fire.
We were already fully-formed
and cognizant of rainbows,
had sought out
and located the throbbing
pulse of the cosmos
in our own feet
before we landed.
And we sowed all that
was left of our home stars
into the seas
and into the cliffs
and into the plains.
After all, it was a fixer-upper,
but it had good bones.

Just needed a little TLC.
We stopped now and then
to look around before
squeezing storms from clouds
and dew from crops.
It's no mystery
we had already sung
the algorithms of a planet
before they could even speak,
had already forgotten
the middle names of asteroids
before they even thought
to look up.
Celestial bodies,
we were and will always remain
aware that no matter where
we go in the universe,
we are already in
space.

The Origin of Moths

We don't remember what came before lavender. Most of us were asleep, resting in leafy cocoons. Something scratched loose our swaddles, scratched stripes into the blank till the lavender began. We woke to the starch sound of scratching and streams of lavender flooding cool over our eyes. Lavender sky where the blank had been. Lavender river coursing over glittering lavender rocks. Our blood, when it spilled, lavender as water. Lavender hills rising. We didn't know to call it sweet. By the time we knew anything, we knew lavender. One day there was a turn.

First the mist, then the berries, then the lavender sound of birds shuddering in a bush. Gone. So much lavender disappearing, draining into the soil. We didn't know names for the colors that came next. The brightest color we called, "howl." Howl bleached the sky, uncoiled into the ocean. Howl water flickered with lavender foam. Then, all the lavender was gone. The flowers disappeared at night. At night we couldn't even see our hands. We named the color of shadow, "blood." It was confusing, but we didn't care. Blood was everywhere. Every night the blood fell, blotting the world blind. It was not lavender, but at night we only had the one color to reckon with, it was a comfort to some.

Days and nights wavered unevenly, we pressed together, praying for the wind to turn to scratch, praying for sleep, for the mists of lavender to bloom again in the bloodish fields. We died together, age after age. Bones emerged from our dead. We stacked them in columns, and the clatter of bones filled the hollow between the hills.

We'd all but forgotten lavender. When She scratched Her way out of the bloody soil and racket of bones, our palms feathered open like howl leaves. Under Her glossy skin, we all saw the moth. A literal moth from an ordinary hill, gauze wings, bloody as night, bloody as underneath, opening and closing inside Her body. Its moth wings breathing under a rope of spine. She put Her hand flat between our breasts. She said, *There is so much extra space inside the body for wings. Space to roll up coils of antennae and tuck them under flaps of ears.*

We thought She was blessing us. Some could sleep again. Some saw lavender when they pressed their hands over their eyes. We wrapped each other in spiderwebs and moss. We coiled vines around the legs of our children. We hummed songs about water dragging bones out to the sea. She helped the last of us back into cocoons. Some of us became moths.

We slide our wings through grass. We have no mouths for sucking nectar. She is far away now. We see Her blinking lavender in the blank dusk like a star.

As It Is in Heaven

On earth as it is in heaven

Thus my path is written

I am Sirius,

My descent from that cosmic star
Was no accident

My emergence into a Babylon of deception and disrepair is far from chance

My resonance with abundance
Reveals who I am

Mr. Black Atlantic,
Child of Kronos
guided by the rings of Saturn

A prodigy of the most high
I exhale my mind into matter

And I've learned that when nothing is mine
the more I have

And for many lifetimes
this soul has been stripped bare

Broken, naked, utter despair

Displaced, erased, defaced,
but it was there
that we were immortalized into stone

And Now wherever upon this land I roam
I am home

Sankofa

but just how far back can I return?

How many of my pasts can I unearth

How much of my conditioning can I unwork

How deep into the soil can I reinter
How much heaven can I endure

How much love can I sow into the earth
So that even if I never touch the fruits of my work

My child's child will never taste this hurt

For I stand on the shoulders of gaseous explosions
Heaven's soldiers who traversed oceans

And through their motions
they reversed the current

So I ride the tide
back on home

I ride the wind
back within

Through breath the revolution begins

BLACK WOMEN
NARRATIVES

Ego Tripping (there may be a reason why)

I was born in the congo
I walked to the fertile crescent and built
 the sphinx
I designed a pyramid so tough that a star
 that only glows every one hundred years falls
 into the center giving divine perfect light
I am bad

I sat on the throne
 drinking nectar with allah
I got hot and sent an ice age to europe
 to cool my thirst
My oldest daughter is nefertiti
 the tears from my birth pains
 created the nile
I am a beautiful woman

I gazed on the forest and burned
 out the sahara desert
 with a packet of goat's meat
 and a change of clothes
I crossed it in two hours
I am a gazelle so swift
 so swift you can't catch me

 For a birthday present when he was three
I gave my son hannibal an elephant
 He gave me rome for mother's day
My strength flows ever on

My son noah built new/ark and
I stood proudly at the helm
 as we sailed on a soft summer day

I turned myself into myself and was
 jesus
 men intone my loving name
 All praises All praises
I am the one who would save

I sowed diamonds in my back yard
My bowels deliver uranium
 the filings from my fingernails are
 semi-precious jewels
 On a trip north
I caught a cold and blew
My nose giving oil to the arab world
I am so hip even my errors are correct
I sailed west to reach east and had to round off
 the earth as I went
 The hair from my head thinned and gold was laid
 across three continents

I am so perfect so divine so ethereal so surreal
I cannot be comprehended
 except by my permission

I mean . . . I . . . can fly
 like a bird in the sky . . .

The Goddess of Anger

Did he touch you?
Did he hit you?
With jagged words,
or closed fist?
Did he laugh at you?
Were you polite even
then— were you lava
under the skin? Then,
let me in. Unsheathe
the dagger of me.
You've tasted pain,
now let me master it.
Let me in. I'll use
the dust of his bones
for tea. I'll rise, vengeful
and caustic, a florid fury—
steeped in so much seething,
I'll make his eyes bleed.
Let me in. I'll dissect him,
unflinchingly, a backhand
slap, a rake of fingernails—
I'll spit my small mercies.
I'll dance on him in stilettos,
paint my toenails "OPI red"
while the blood congeals.
Let me be your ignition point,
your pitch, the whoosh
of hot, sweet breath.
I'm all your swallowed heat
simmered into flesh.

Let go of fear, of retribution.
I too, can lift burdens.
Let go of decorum and shame.
Ride Rage until it bucks,
then jump on it again.
Damn it, let me, let me,
Let. Me. In.

Friendly Skies, or Black Woman Speaks Herself into God

—we're taxiing at an airport named after american president ronald reagan. people tell me he was an american hero. sometimes, labels are jumbled in the big dark bag we call manifest destiny. sometimes, things get lost in its velvet mouth.

—as we move across the land in a machine built for sky, we wait for the flight attendant to tell us how to be safe, how to will ourselves alive thirty thousand feet in the air if we find ourselves falling to an inevitable end. how to build a raft from breath alone to face a gulping sea.

—our attendant, Valerie, is Black. her braids hang, a holy rope, in a high ponytail. her eyes, divinely familiar. when the disembodied voice booms over the plane speakers, we see her mouth moving in time with its words. *to ensure your safety*, she says. *secure your mask before helping others.* her lips make the shape of our salvation.

—reader, this might be how you felt sitting in the movie theatre's strobelit box when you saw *Black Panther*, when you realized a Black person could feel as big as God, could save the world and make it home in time for dinner, run a whole country against no white background, could know all the land and its secrets *and* roam the afterworld, leisurely resting after a life of nothing colonized, after all the sweat of work done just for self, of work unstolen and unenslaved.

—and i know Valerie isn't God but i also know that she is, standing here, commanding this voice we thought was faceless, using her earthly body to show us the way. here, with her hands which will pour us fizzy drinks in our little plastic cups, usher trash from our laps into an unknown abyss— i know if this thing goes down in a fiery cocoon, she will part every sea to cradle us, she will speak to us through the fire—*you are that you are.*

Looking for Hope, Kevin Johnson

Mitochondrial Eve

I am. I am the beginning. I am.

I birthed the world. I clothed this Earth
with my children long before hate colored it.

Some call me Homo sapiens, and some, Eve.
If you must know, child, I am Africa—
it makes no sense dividing me by 5.

I am not primitive. I am not developing.
Erase your race. Take out your tribe too.
I am not what you say I am.
A child never grows bigger than her momma.

What you will know tomorrow I began yesterday.
Long, long ago, I carved the Ishango Bone
and made the first paper from papyrus plants
and the first pen from Juncus maritimus reed,
ink from ochre soot and dipped in water.

With my bare hands I built the Kraals
and raised the Axum Obelisk to proclaim me,
with ease, like ants, I formed the Pyramids
and made the Great Sphinxes in my sunrise;
I molded the Ziggurats and the Olmec heads
and the wonders you are yet to uncover.

You call me Shang. Minoa. Etruria. Mycenae. Anatolia.
Sumer, you say. Canaan. Maya. Axum. Nubia. Phrygia.
I hear Washitaw. Dogon. Pelasgia. Dravida and others.
Whatever you think I am, do not labor
to lock me out of my home again:
no white no brown no black no red;
you are a human being—you are me.

Resolving Sorrow, Kevin Johnson

La Diablesse

She never walks, fully, on the road.
She wears a dress a shade of blue
that doesn't exist, a color my mother
saw when she nearly died projecting
me into this world, and the sky
and water turned this godly
shade; as a seamstress, an artist,
she was never satisfied again.
This woman here is best friends
with the dark and flora—we don't talk
about where she comes from, we wait
for a man to drive by this lonely road
at night, spot her, stop her. She wears a hat
like a tourist, which she is, one leg in this land,
one leg outside a slit, both hands grasping.
Every man, I suppose, must compare to
the original, the decadent dealmaker:
I never wondered how close she was with
Him, how deep she dipped her black toe
in the role of Faust. I imagine she is fine
with the skin on her face, its leather and fur—
the hat has a purpose, see, no man would go
willingly. At the sound of his chirps,
she casts a spell, and here is where I get jealous.
When I was younger, a man followed me home
and cornered me behind my father's garage,
told me to lift my dress, remove my panties.
Within spitting distance of hammers, drills and
acid, I did not comply, and then I do not remember,
but perhaps I saw that same blue, the same blue
this woman swishes, this woman animals
and goddesses around night after night.

The spell is in the disappearing, in the wild way
he wails through the trees. When I first heard
of her, I thought she'd have sex with them before
their demise. Later, I realized it was never
about sex, it was about power. I want to see
her whole face, her victory pose, heifer on
a high horse silhouetted by the moon as the man
crashes to his grave, but there are different kinds of
power, too. When I walk alone, I walk half on grass,
half on the street. No one stops me these days,
I wear pants, I bottle the lore my mind allows me to
think about on days I want to be controlled by
a demon, dream about blue when I want to die.

Maurya Kerr

Sonnet for the Black Girl

for Nubia, Wonder Woman's Black Twin Sister

Nubia hurls orbs into an owl-lit
Sky, one-by-one, until her shoulders, arms,
Wrists ache. Dusk time is slow time—in the wane
She rests, watches, waits. Sometimes she is lonely
As a star, other times remembers stars
Are never lonely. She wonders about
Monozygosity, multiplicity,
Mass, why it remains so dark inside the
Beast. The recognition of debt, the who,
Why, hue of history. She is both moon
And landing, meteor and fall, mythos
And umbra. Oh dear love, dear bane, dear bright,
Born of dark clay not light—grave starry vast
Of justice. Sonneted wondrous black.

Arch Angel, Karo Duro

Tony Medina

Well, You Needn't

Since vinyl is making a comeback
Along with fur slides, Snuffleupagus
Eyelashes and Cousin It weaves,
I must confess, this toxic masculinity's

Getting on my last recorded nerve.
Mofo's gotta come correck, as my
Auntie used to say. I'm often
Offended by these tone deaf aggressive-

Ass superheroes with their disappearing
Acts, jumping out windows, hanging
Off fire escapes well after midnight
When my old man didn't even come—

Nor did I, which is the goddamn point.
But I'm not one to gossip, 'cause I'm
A lady. But this whole notion of coming
And going when you good and well please

Is really wearing out its welcome—
And my one good nerve. I'm not with that
Ditzy Lois Lane shit, I'll cut a motherfucker,
Cobwebs, cape, red boots, and all. Shoot,

My mama didn't raise no fool. I know when
A mofo is not truly interested in me
But for one thing. Hell, I'm stressed but
I'm damn sure no damsel in distress.

Yet I must confess—that I carries a
Razor blade between my cheek and gum
Like the chewing tobacco my grand-
Daddy used to dip and snuff. And I

Knows how to use it. So if you don't
Wanna lose it—or me for that matter—
Stay away from the motherfucking
Window.

Why Black Women Write Horror Stories: A not-quite-fictional survey of Black female horror writers in the US

I'm thinking a lot about how I use Afrofuturism in terms of processing trauma as a horror writer. . . . The piece of it that most attracts me is how to take evil . . . and create sort of a fun house, mirror-image of it that is not the thing itself but a visual or written expression of a thing that is frightening or frightful . . . and creating survivors.—Tananarive Due at "What Was, What Is, and What Will Be: A Cross-Genre Look at Afrofuturism"

Black women write horror stories
because: US history should be told as a scary story
because: Slavery was a living nightmare
because: Generations of Black people survived mass
kidnapping, physical and psychological torture, rape and
murder, and systematic dehumanization
because: Look at where we find ourselves today

Black women write horror stories
because: Black people still fear for their lives
because: White people are still afraid of their own shadows
because: Most folks refuse to actually look in the mirror
because: They want good and evil to be black and white

Black women write horror stories
because: We have to exorcise these demons
because: It isn't just all in our heads
because: The monsters we have to face are real
because: This country fed upon the flesh and blood of our ancestors to
bring itself to life

Black women write horror stories
because: Black women have seen some scary shit
because: It isn't safe to be black or female

because: The past isn't dead even if it's been buried
because: The future could be even scarier

Black women write horror stories
because: These are the lessons that Black kids need to learn
because: What you don't know can get you killed
because: Happy endings don't tell the hard truths
because: There's no sense in lying about it

Black women write horror stories
because: We are the hopes of our mothers
because: We are the mothers of hope
because: We know how to find our way in the dark
because: We've done this before

Black women write horror stories
because: It's time to right the wrongs that have been done to us
because: This is how we help our people make it out alive
because: We have always been our own greatest heroes
because: Telling our stories just might change history

Dark & Lovely after Take-Off (A Future)

Nobody straightens their hair anymore.
Space trips & limited air supplies will get you conscious quick.

My shea-buttered braids glow planetary
as I turn unconcerned, unburned by the pre-take-off bother.

"Leave it all behind," my mother'd told me,
sweeping the last specs of copper thread from her front porch steps &

just as quick, she turned her back to me. Why
had she disappeared so suddenly behind that earthly door?

"Our people have made progress, but, perhaps,"
she'd said once, "not enough to guarantee safe voyage

to the Great Beyond," beyond where Jesus
walked, rose, & ascended in the biblical tales that survived

above sprocket-punctured skylines &
desert-dusted runways jeweled with wrenches & sheet metal scraps.

She'd no doubt exhale with relief to know
ancient practice & belief died hard among the privileged, too.

Hundreds of missions passed & failed, but here
I was strapped in my seat, anticipating—what exactly?

Curved in prayer or remembrance of a hurt
so deep I couldn't speak. Had that been me slammed to the ground, cuffed,

bulleted with pain as I danced with pain
I couldn't shake loose, even as the cops aimed pistols at me,

my body & mind both disconnected
& connected & unable to freeze, though they shouted "freeze!"

like actors did on bad television.
They'd watched & thought they recognized me, generic or bland,

without my mother weeping like Mary,
Ruby, Idella, Geneava, or Ester stunned with a grief

our own countrymen refused to see, to
acknowledge or cease initiating, instigating, &

even mocking in the social networks,
ignorant frays bent and twisted like our DNA denied

but thriving and evident nonetheless—
You better believe the last things I saw when far off lifted

were *Africa Africa Africa*
Africa Africa Africa Africa Africa . . .

& though it pained me to say it sooner:
the unmistakable absence of the Great Barrier Reef.

AFROFUTURISM & SPECULATIVE POETRY

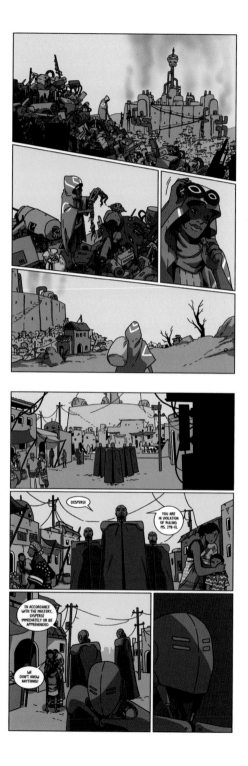

FATE: Fight for Idriss,
Jamal A. Michel

the moongazer speaks on longing

I will not ask you where you came from
I would not ask it neither should you
—Hozier

let me say this: I was human once
and so frail, the weight of a machete
could split my back working in these fields
we harvested cane all
throughout the day longing for the call of night,
the sweet cool black hollow it would bring. even now
I remember my woman—mighty as she
was, crying after a day's work my own
hands trembling as we suckled stolen cane
together, that sugar the only thing that
cared if we lived or died. I buried her
in those same fields we slaved, then started walking
into the sweet of a velvet dark
kept hearing my love
calling me deeper still. I grew wild
in my grief, dreamt her a moon
reaching down, until I grew taller
to meet her voice, a giant as mighty as love
oh, my god, what stories these white men
will tell! let them say I would
kill my own blood rather than let
them eat, stalk sugarcane fields
as i would my own heart. you
know me, what i have done
to find my love: look at her
crowned by nothing but the stars
in this bowl of sky. I've earned the right
to gaze on her.

Afronaut, Cagen Luse

give them the moon—here

you are on top of the dog riding it like it's a horse I am underneath
drinking its blood milk we are an unlikely two & make the dead
jostle oak leaves around in their mouths you & I are one in the same
beasts we are riding to see the last city turn to ash

the sky the color of burning a thousand mountain dew bottles
in every way you know one can be alive I am dead but like all the dying
dogs I wake up young & not dying have a not mouth but a scar full of teeth

all the young dogs wake up ready to hunt pastures in packs all the young
dogs have the insides of young men I was born but I paid in no treasured
bones in the land of before & after I comb the last horse's mane like a
good boll-weevil like it was the top of my own cowardly head

a dead man & the moon will enter the last abandoned mall to perform
an ancient practice in the food court one will eat the other you & I
will wait in the molten parking lot to see what will emerge man or
moon moon or man

what could turn me blue like this

all around me snow was falling

the guards left their post

with nothing but hearts to guard

my heart needs a guard a gallant

& no one is guarding our hearts

the evil has entered

the evil has entered my heart

& sometimes I can taste the blood milk

& it soothes my soul

all night I tried to forgive the moon

& all night I failed & looked like my father

bent over his never working truck
does the moon guard my dreams?

It must make its own face in the sky

all around me snow was falling

people were getting put into the ground

there was a long line of people waiting

to be put in the ground

this is my body one body yell to another

then we all ducked down

& that is what makes us

kin
that we must die

now I can see

the song goes &

it is true

Sci-Fi

There will be no edges, but curves.
Clean lines pointing only forward.

History, with its hard spine & dog-eared
Corners, will be replaced with nuance,

Just like the dinosaurs gave way
To mounds and mounds of ice.

Women will still be women, but
The distinction will be empty. Sex,

Having outlived every threat, will gratify
Only the mind, which is where it will exist.

For kicks, we'll dance for ourselves
Before mirrors studded with golden bulbs.

The oldest among us will recognize that glow—
But the word *sun* will have been re-assigned

To the Standard Uranium-Neutralizing device
Found in households and nursing homes.

And yes, we'll live to be much older, thanks
To popular consensus. Weightless, unhinged,

Eons from even our own moon, we'll drift
In the haze of space, which will be, once

And for all, scrutable and safe.

My God, It's Full of Stars

1.

We like to think of it as parallel to what we know,
Only bigger. One man against the authorities.
Or one man against a city of zombies. One man

Who is not, in fact, a man, sent to understand
The caravan of men now chasing him like red ants
Let loose down the pants of America. Man on the run.

Man with a ship to catch, a payload to drop,
This message going out to all of space. . . . Though
Maybe it's more like life below the sea: silent,

Buoyant, bizarrely benign. Relics
Of an outmoded design. Some like to imagine
A cosmic mother watching through a spray of stars,

Mouthing *yes, yes* as we toddle toward the light,
Biting her lip if we teeter at some ledge. Longing
To sweep us to her breast, she hopes for the best

While the father storms through adjacent rooms
Ranting with the force of Kingdom Come,
Not caring anymore what might snap us in its jaw.

Sometimes, what I see is a library in a rural community.
All the tall shelves in the big open room. And the pencils
In a cup at Circulation, gnawed on by the entire population.

The books have lived here all along, belonging
For weeks at a time to one or another in the brief sequence
Of family names, speaking (at night mostly) to a face,

A pair of eyes. The most remarkable lies.

2.

Charlton Heston is waiting to be let in. He asked once politely.
A second time with force from the diaphragm. The third time,
He did it like Moses: arms raised high, face an apocryphal white.

Shirt crisp, suit trim, he stoops a little coming in,
Then grows tall. He scans the room. He stands until I gesture,
Then he sits. Birds commence their evening chatter. Someone fires

Charcoals out below. He'll take a whiskey if I have it. Water if I don't.
I ask him to start from the beginning, but he goes only halfway back.
That was the future once, he says. Before the world went upside down.

Hero, survivor, God's right hand man, I know he sees the blank
Surface of the moon where I see a language built from brick and bone.
He sits straight in his seat, takes a long, slow high-thespian breath,

Then lets it go. *For all I know, I was the last true man on this earth.* And:
May I smoke? The voices outside soften. Planes jet past heading off or back.
Someone cries that she does not want to go to bed. Footsteps overhead.

A fountain in the neighbor's yard babbles to itself, and the night air
Lifts the sound indoors. *It was another time*, he says, picking up again.
We were pioneers. Will you fight to stay alive here, riding the earth

Toward God-knows-where? I think of Atlantis buried under ice, gone
One day from sight, the shore from which it rose now glacial and stark.
Our eyes adjust to the dark.

3.

Perhaps the great error is believing we're alone,

That the others have come and gone—a momentary blip—

When all along, space might be choc-full of traffic,

Bursting at the seams with energy we neither feel

Nor see, flush against us, living, dying, deciding,

Setting solid feet down on planets everywhere,

Bowing to the great stars that command, pitching stones

At whatever are their moons. They live wondering

If they are the only ones, knowing only the wish to know,

And the great black distance they—we—flicker in.

Maybe the dead know, their eyes widening at last,

Seeing the high beams of a million galaxies flick on

At twilight. Hearing the engines flare, the horns

Not letting up, the frenzy of being. I want to be

One notch below bedlam, like a radio without a dial.

Wide open, so everything floods in at once.

And sealed tight, so nothing escapes. Not even time,

Which should curl in on itself and loop around like smoke.

So that I might be sitting now beside my father

As he raises a lit match to the bowl of his pipe

For the first time in the winter of 1959.

4.

In those last scenes of Kubrick's 2001
When Dave is whisked into the center of space,
Which unfurls in an aurora of orgasmic light
Before opening wide, like a jungle orchid
For a love-struck bee, then goes liquid,
Paint-in-water, and then gauze wafting out and off,
Before, finally, the night tide, luminescent
And vague, swirls in, and on and on. . . .

In those last scenes, as he floats
Above Jupiter's vast canyons and seas,

Over the lava strewn plains and mountains
Packed in ice, that whole time, he doesn't blink.
In his little ship, blind to what he rides, whisked
Across the wide-screen of unparcelled time,
Who knows what blazes through his mind?
Is it still his life he moves through, or does
That end at the end of what he can name?

On set, it's shot after shot till Kubrick is happy,
Then the costumes go back on their racks
And the great gleaming set goes black.

5.

When my father worked on the Hubble Telescope, he said
They operated like surgeons: scrubbed and sheathed
In papery green, the room a clean cold, a bright white.

He'd read Larry Niven at home, and drink scotch on the rocks,
His eyes exhausted and pink. These were the Reagan years,
When we lived with our finger on The Button and struggled

To view our enemies as children. My father spent whole seasons
Bowing before the oracle-eye, hungry for what it would find.
His face lit-up whenever anyone asked, and his arms would rise

As if he were weightless, perfectly at ease in the never-ending
Night of space. On the ground, we tied postcards to balloons
For peace. Prince Charles married Lady Di. Rock Hudson died.

We learned new words for things. The decade changed.

The first few pictures came back blurred, and I felt ashamed
For all the cheerful engineers, my father and his tribe. The second time,
The optics jibed. We saw to the edge of all there is—

So brutal and alive it seemed to comprehend us back.

The Universe: Original Motion Picture Soundtrack

The first track still almost swings. High hat and snare, even
A few bars of sax the stratosphere will singe-out soon enough.

Synthesized strings. Then something like cellophane
Breaking in as if snagged to a shoe. Crinkle and drag. White noise,

Black noise. What must be voices bob up, then drop, like metal shavings
In molasses. So much for us. So much for the flags we bored

Into planets dry as chalk, for the tin cans we filled with fire
And rode like cowboys into all we tried to tame. Listen:

The dark we've only ever imagined now audible, thrumming,
Marbled with static like gristly meat. A chorus of engines churns.

Silence taunts: a dare. Everything that disappears
Disappears as if returning somewhere.

Einstein Defining Special Relativity

INSERT SHOT: Einstein's notebook 1905—DAY 1: a theory that is based on two postulates (a) that the speed of light in all inertial frames is constant, independent of the source or observer. As in, the speed of light emitted from the truth is the same as that of a lie coming from the lamp of a face aglow with trust, and (b) the laws of physics are not changed in all inertial systems, which leads to the equivalence of mass and energy and of change in mass, dimension, and time; with increased velocity, space is compressed in the direction of the motion and time slows down. As when I look at Mileva, it's as if I've been in a space ship traveling as close to the speed of light as possible, and when I return, years later, I'm younger than when I began the journey, but she's grown older, less patient. Even a small amount of mass can be converted into enormous amounts of energy: I'll whisper her name in her ear, and the blood flows like a mallet running across vibes. But another woman shoots me a flirting glance, and what was inseparable is now cleaved in two.

Whitey on the Moon

A rat done bit my sister Nell.
(with Whitey on the moon)
Her face and arms began to swell.
(and Whitey's on the moon)
I can't pay no doctor bill.
(but Whitey's on the moon)
Ten years from now I'll be paying still.
(while Whitey's on the moon)
The man just upped my rent last night.
('cause Whitey's on the moon)
No hot water, no toilets, no lights.
(but Whitey's on the moon)
I wonder why he's upping me?
('cause Whitey's on the moon?)
I wuz already paying him fifty a week.
(with Whitey on the moon)
Taxes taking my whole damn check,
Junkies making me a nervous wreck,
The price of food is going up,
An' as if all that shit was't enough:
A rat done bit my sister Nell.
(with Whitey on the moon)
Her face and arm began to swell.
(but Whitey's on the moon)
Was all that money I made last year
(for Whitey on the moon?)
How come there ain't no money here?
(Hmm! Whitey's on the moon)
Y'know I just about had my fill
(of Whitey on the moon)
I think I'll send these doctor bills,
Airmail special
(to Whitey on the moon)

Fireworks

When electrons are taken
from their nucleus
the atom emits
light like when we lose
a black child, see fireworks
across a chalk outlined sky
and remember we are only
beautiful when young and covered
in lithium crimson, left
in the night for hours after
our bodies fall into tiny photons,
fireflies who couldn't find
their way home from the
convenience store.

In Defense of Passing

Most of us call it *cloaking*,
though the academic
term for the practice slides

just as smoothly off
a teenager's tongue:
holographic deracination.

Within days of wide-scale release,
the *Times* will hail this device, its
attendant social phenomena,

as triumphs of modern technology,
inevitable advance given
the speed of post-racial desire,

how expensive it is
to purge the murk
from an infant's skin

by most other means.
The machine's inventor
will make no such claims.

A plainspoken woman, she was.
Stanford grad, white as a lab
coat. Cited her time overseas

as primary inspiration;
all the suffering she'd seen
caste cause. The device came

to her in a lucid dream, this silver ellipse
small enough to wear on the wrist
or lapel, just one touch

and any future you choose could be
yours. Soft, false flesh, draped
like a new lover over your body

and just as clumsily until you work out
the rhythm of it, the slang,
how to maneuver this

cold glass suit, light as it is.
Believe it or not, protest
didn't last long.

Sky-high pricing kept the cloaks
an upper-class concern for months, years
before poor folks got a hold

of any prototype worth the worry.
Once they did, you would think
they had stolen something worth more

than a date with the quarterback,
or a job interview. You would think
they had killed someone important,

or blown up the moon, the way cops
flooded the slums, clubs in hand,
beating the color off of them.

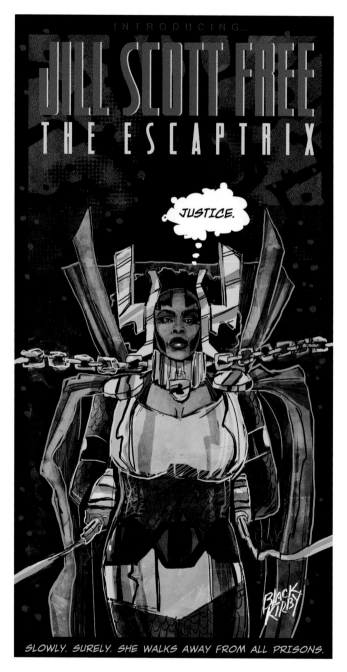

Black Kirby, John Jennings

The Silver Screen Asks, "What's Up Danger?"
After We Enter

a lobby shaped like a yawn, lined with lodestone
leftover from making the marquee. The congress

of picture shows and pulp flicks it seems
named this movie house, the Senator.

Or maybe the city loves to signify. I guess
it matters little to a mill worker,

stevedore, or teamster how the name
came to be. My son and daughter

who will never walk home covered in soot,
longing for a moment in the mud room

to be responsible for nothing
but removing a coat, unlacing a boot,

my children slide like two slightly rusted magnets
toward the aluminum rail posts guarding

the popcorn counter. All the candy encased
in glass like masks in a museum. They've forgotten

our talk in the parking lot about Miles Morales,
about his animated face being so near to us

even without 3D, that this Afro-Latino Spider-Man
could be our cousin, in a more marvelous universe.

But when they sit in the Senator's un-stadiumed
seats, with the ghosts of reel-to-reel clicking

their tongues, what I see on my children's faces
is not a season of phantasmal peace, but what's left

when the world's terrors retreat. Their whole brown
skin illuminated, like a trailer for another life.

Octavia Butler (73rd Birthday), John Jennings

Banner Day

Y'all gon' make me lose my mind
Up in here, up in here
—DMX

I had a stunt double that played Othello in blackface.
Crypto Stay Puft Marshmallow mofo said, *I wanted to be*
Black a more. Had a poster of Bert Williams in his trailer.
I knew the signature wasn't his by the way he neglected
To dot the I's and cross the T. Bert didn't do that shit.
He'd come to the set whistling Dixie, then turn sideways
On his makeup chair singing, *You can call me Al . . .*

Capping that off with an off-the-cuff—*Mammy!*
As if he just took a swig of Coke or snorted the shit.
One time he bragged about doing Repertory Theater
In the Chi playing a broke-down Hamlet. *I really wanted*
To play Macbeth, but the whole play was a bloody mess,
He said. One day he came to the set tore the fuck
Up. His breath could burn your brow. I could hardly

Decipher the script at the table reading. Rolled up
To me and said, *What makes you so special? I'm the one*
Doing the heavy lifting, taking all the hits and falls. I cut
My eyes to him bearing down deep into his blue-eyed soul.
Said, *Don't let this light skin fool you. That fucked up*
Weave and Bert Williams doesn't give you a pass, mane.
Give you that one-drop molly-whop—ya feel me?

I will still open a can of green whoop-ass on you
Sure as you're standing in the shadow of my piss
With that slushy in your hand smelling like Cutty Sark
And yeasty Wonder Bread sweat, Opie. Then some cat
From Costume carted him away like Blanche DuBois and
Sprayed his big ass down with green paint, dressing him in
A lobster bib and tore up terrible twos toddler trousers.

Heliocentric

If I beg and pray you to set me free, then bind me more tightly still.
—Homer

I'm striving to be a better astronaut,
but consider where I'm coming from,

the exosphere,
a desk where the bluest air

thins to a lip. Impossible
to know the difference

from where I sit and space.
I promise I still dream

of coming back to you—settling
on your yellow for the kitchen.

And we won't fight.

Not in this manifest. Not over the crumpled bodies
of laundry. We won't row over the
nail polish, its color,

the spilled sun. Inspiration
is the deadliest radiation.
It never completely leaves the bones.

You know.
 From here,

there are no obstructions
but the radiant nothingness. An aurora
borealis opens

like a fish. This. To the pyramids, yes,
to a great wall. And there you are,

moving from curtain to curtain. O, to fantasize
of having chosen
some design with you.

But the moons over Jupiter. But
asteroids like gods
deadened by the weight of waiting. I remember

you said pastel

for the cabinet where the spice
rack lives. That I ought've picked you

up flowers when I had a chance. Daisy, iris, sun.
Red roses. Ultraviolet,
the color of love
(what else but this startles the air open

like an egg?).
I'm really trying

to be better, to commit
to memory the old songs about the ground,
to better sense your latitudes,

see the corona of your face.
Take your light

as it arrives. Earth is heavenly
too. But know that time is precious
here. How wine waits years and years to peak.

What is there to do: I've made love
to satellites in your name.

I'm saying I don't know when I'll
return. Remember me, for here are

dragons and the primitive song of
sirens. Stars that sway elysian.
Ships that will not moor, lovers

who are filled with blood and nothing
further. Who could love you
like this? Who else will sew you in the stars?

Who better knows your gravity and goes
otherwise, to catastrophe?

I've schemed and promised
to bring you back a ring

from Saturn. But a week passes, or doesn't

manage. Everything steers impossible
against the boundless curb of light.

Believe I tried
for you. Against space. Time

takes almost everything
away. To you. For you.
A toast to everything incredible. I almost wish

I'd never seen the sky
when always there was you. Sincerely,

Untitled

Once knew an android with a self-destruct button. They were not unlike other androids: part biology, part technology. Brain was GPS wireless touch-tone database-ready instant message capability 250 channels 55 kilobytes per second unlimited text with Bluetooth on blue ray high def first 1045 hours free. Body was built with beta-carotene high fructose fluoride peroxide 19, protein electrolyte supplements with extra pulp, usually injected with one gulp. Everything the body needs, except this one had a self-destruct button. This, too, was not uncommon, nor easily accessible: it'd be a shame to bang one's elbow and suddenly self-destruct. Had to be in a certain position, a number of positions, and several buttons need to be pushed to initiate destruction. Still, this android contemplated pushing the button. What good is a button if it never gets pushed? And what would happen? Would there be an end to the laughing, an end to the tears? Would fears of tomorrow finally be put to rest? Would they even be missed? There are so many androids ready to take their place. And what would their final facial expression be? With this they decided to get it removed. Some additional chemicals and a new cut of hair, they simply forgot it was there. They went about their life of labor and logarithms, making logic out of an irrational world and promptly doing what they were told

until they grew obsolete, failing to explode.

SPACESHIP FOR SALE

2020 was a light year for you. Off-drive, every word
dropped From warp and here you are:

A world away . . .
Kraal, home; stop, alien, Your urn-sitting for
saturnalia.

"Your hooptie starcruiser
Has a busted thrive-shaft
Plus you're real low on
Anti-frieze & Dark Matter."

 - Prometheus is an okay
 Mechanic, but he's no Ma'at

It felt good when starfleet degreed
You, but what's a Ph.D. in astromystics To the amoebas in your
motherboards Baptized in nanobots?

 The future is hypnapagogic!

But you still have to eat

So,

Space ship for sale: the tachyons are in their indigenous
casings | there's a hitch in the clutch but no glitches | alloy rims |
there might be a ding or two on the railgun's side panel but
no worm holes | factory parts never been piecemealed; As-is.
Sirius inquiries only.

Fair Gabbro Travels Time to View the End of Days

Is this I? brown and vast and sweltering in cobalt.
in what century did my belly devour the moon?
i am my own earth, how monstrous my pulchritude,
with volcanos astriding my brow like a tiara . . .
this choreography of comets as a crown, tachyons
erupting as sonnets from my forehead . . . i am a small
dense sun! *a white dwarf!* and every solar system lain
at my feet like an endowment; this dowry for my death . . .

it will take millennia for the Milky Way to have trained
past my coffin, each star stopping to kiss my hand in casket;
oh, how the nebulae weep for me! and still yet i'm birthing
planets from the womb! each afterbirth its own atmosphere!
a nativity of meteorites and asteroids . . . how many
Gods have grown complete and come undone in my shadows?
how many Big Bangs have baptized on my tongue, in my tears?
how did i grow to deserve such affection?
how un-calculable the songs collected in the folds of my skin;
this orchestra of a trillion origins between my thighs . . .

quite the maestro i've become.
this nacreous black bauble born from a fog bank;
this black start diesel sheathed in a blanket of stars . . .
what a distance i've acquired, *from Uhlanga to Eternity!*
who knew the tip of my switchblade would be a fairytale?
how did i ever come to pass: *this pampered fable born*
in a season of blood loss from a small drop of motor oil
hissing hotly in its clamshell.

how sublime, how supreme,

 my joyous songs a sheen of stretchmarks
 across the breastmeat of the universe.

i am fully seen. i am forever devoured.

and deep into the end of time, I crack open / only now.

One day the sky began to weep and did so for 300 days

there were those who grew tired of waiting,
filled suitcases with half their lives,
then ran towards Mars or any place far away

we watched from the windows, saw the water rise and gather them up
yet when it settled there was only silence

after each death, it was as if the sky wept more perhaps on our behalf
and life as we knew it, slowly became the color of heartache

my people made no attempt to leave,
common sense persuaded us to stay
considering no one amongst us could swim.

over time we learned a thunderstorm is also a sermon
and water, like all living things, is from God, but it will still kill you

I am writing to tell you the world we came from could not be mended.
That we never learned to swim. We flew away

Igbo women took care of our bodies,
when we only wanted food, they showed us how to be still,
how to use our tongues, to fold and carry what we'd been trained to
season and swallow

At night they would whisper, *"the universe is inside your body, the map
for moving forward lives in your chest, there are wings in your back but you
must find them alone."*

I am writing to tell you that pain is not the best teacher but it comes with
the privilege of being alive. Time is real but also a creation of men who
invaded our home.

I came to measure each day by dreams,
and the disappearance of those who flew away before the arrival of the sun

I am too young to understand inheritance,
but some say our ancestors could walk on water or across the sky
that the world was never full of darkness
because stars were embedded in their skin.

I am writing to tell you, we refused to drown.
We found our wings, and we are free in a world beyond this one

Something we could not see held everything together,
one day it snapped, and the sky wept for 300 days.

This letter is for those who cannot swim—those who will learn to fly after me.

III.

|universe|

when we arrived we realized our space shuttle had been damaged quite
a bit especially after she told us she was in pain. we tried desperately
to fix her before we landed but you can only do so much when you are
in midair when gravity is reluctant to let you survive when the kids are
yelling about trying mcdonalds french fries & something called a hot
dog for the first time. we let ourselves adjust to breathing & it
felt as though we were in tiny coffins as if we had been squished inside a
boat & left to sit in our own feces. we wondered why (on earth) it smelled
like shit (to us).

|copycat universe|

we worked on the space shuttle ship to the best of our natural ability but
she still had a slow yellow limp & systemic pain held in her motherboard.
we do want to leave this planet but we don't need to leave (right now). the
repairs on the one hand seem minimal but on the other hand seem as if—
it could take—years. it is hard to say in the state (we are in). she has asked
us, our space shuttle ship, to go on without her. as in let her rest. let her
sit. cover her & keep going. of course we don't like the idea of her being
tied (to this earth) |especially| with her ankles bound to soil |especially|
with the tree like branches (on her back.) our space shuttle ship is an
irrepressible one. & (we) the ones who traveled will always be thankful.
we were told to leave our 3rd eyes in our space shuttle ship in their cases
with their own mothers. the mothers of the 3rd eyes see (it all) & they have
told us not to sleep for this reason we have been asked to avoid
most things entertaining.

apocalypse (400)

say what

the new girl arrived with her hands inside her mouth & her voice in her pocket. & you might think this is just a cool way of telling the story dear reader, i am telling you the truth. & when we asked her all the usual questions she pointed to her left pocket for the answers & there we found her voice box decorated in black paper & red glittering stars. the voice coming from the voice box was not at all what we expected but then again what does anyone expect from a voice box? what does anyone expect from a time such as this?

Untitled

talk about rockets.
I want to
but not as an object so
bespoke or petal-dressed
glared red with chains
passengers
and hymns. Nor silver flags
parapet like spades. People
who can fly
unwoven m
metal baskets
that free. Get it and gather these folks
into grease
newly formed. 'Cause one
makes up
freedom
swimming or walking
unfurling wings
with magnanimity.
Say this
we are leaving. Say
fuck America
the mothership is here. See this
sword like
bursting through
cloud
fold.
While we sit and taste this kinte-
rimmed cup
bliss all
of it.

us spent
 fat
 and full. Watching through space windows.
 The seat of
 this country's
 open purse.
Trauma finally receding
 receding
 into
 ground
 ash
 and
 and

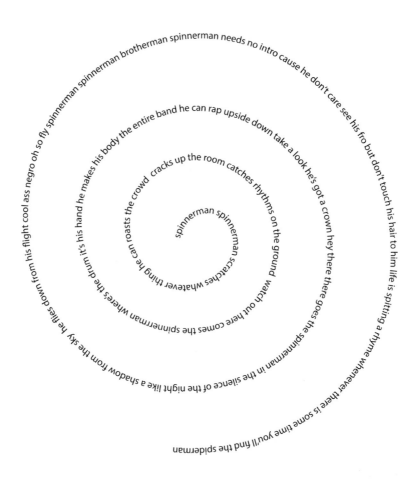

spinnerman spinnerman brotherman spinnerman needs no intro cause he don't care see his fro but don't touch his hair to him life is spitting a rhyme whenever there is some time you'll find the spiderman in the silence of the night like a shadow from the sky he flies down from his flight cool ass negro oh so fly spinnerman spinnerman he makes his body the entire band he can rap upside down take a look he's got a crown hey there there goes the spinnerman in the it's his hand he makes his body the entire band he can rap upside down take a look he's got a crown hey there there goes the crowd cracks up the room catches rhythms on the ground watch out here comes the spinnerman scratches whatever thing he can roasts the crowd where's the drum it's his spinnerman spinnerman scratches whatever thing he can

Lyrae Van Clief-Stefanon

excerpt from

FUGUE: THE SIGHT

Seeing

I *saw it*, I said again & again
whenever anyone asked how
I knew what was coming
Oh say can't you see...? not just
any old saw—: my friend plays
the saw with bow—: bends
the blade toward itself until
the spooky notes warp—: woo
like ghost anthems rhetoric
haunts haunted as my mama's
take on the Word my country
shrugs off my possession will
never stand for *my my*—: butter
wouldn't melt in its mouth so
shutting my own—: I :—fill
my friend's] Miss Ann [glides
from her seat in the audience to
take my place at the podium as
rhyme and—: reason calls for
doubling I am doubling down on
breathing

I, Eye, Aye

This ain't no freak show—: you said
to listen I listened with my whole body
tutored—: by blind love—: in
attention—: catching snagged by
what is combed—: a saw like makes
like—: splitting horsehairs reeds turns
song :—but what isn't—: listen
woo woo's like—: a fine romance
weaves :—wig-snatching through—:
records seasons pizzicato & trilling
plucks—: nerves—: glosses
fade—: to a smooth Black feedback
in a hollow belly holding place—:
Southern Switzerland Mississippi's
g/listening sky—: rendered orange
volunteered from a—: scraped throat
sirens whistles dogs closing in—:
there's] a man [*in this house* he can't escape fire
fire his burning face I see in flames to come
how what's coming just plays until we're
bent blended brazen breathing still

Is Believing

triangle breathing
dancing
bird watching—:
red pileated—: or
palliative a meeting of
the times tonguing
this love of mine:—
a canary's song—:
whatever compromise
faith is:— believe my
painful :—hungry
loop lessons—: ensigns
her else-altered all-that
that-close to closing in
city-sonata—: rising
hoarse—: saxophoned
] Crow Jane [cawing
critical vision resounding
combed over *re: visitations*
a note—: circular—:
holding our breath

By the Blood Moon Bridge

One by one they come
some pushed, others tired
and willing. Wide bewildered
eyes frightened, adjusting
to the new deep darkness
searching the faces, rivers, trees
for the familiar.

Two by two they come
some high step, others tiptoe over
bridges suspended over, fresh river
waters, marching. Pubescent skins tattooed
with bruises and keloid scars lined
beneath. Grown in hard like gristle
swollen, unforgiving and soldered
to hearts, squeezing, choking, holding on
to the familiar.

Then the babies come,
newborn fawns stumbling over limbs that
fold in on themselves, red imprint of
Death still coiled round their throats
crawl in some do, sniffing out vacant
eyed mothers, wilting milkweeds leaking
agave nectar from swollen breasts. Lost
abandoned pairs, Yemoja & child
settle for the other, reaching out
for the familiar.

The new souls, when they wake from the stupor
to know what has become of them,
fall to their knees and claw at the dirt
with vamp glittered nails. They
wail out to karmatic gods of justice
who never came to the rescue. They
shout *Oh, Lord why was I forsaken*
. . . and the Aje laugh.
 for there is no forgiving of trespassers here.

They roll seen-it-all eyes and suck teeth
between clay pipes and dark lips, they
hold no pity for the new souls, they
wave apathetic hands, shoo them away. They
are about the business of restitution.
 & hot bellied cobras slip from warm earth

They kneel at the river
scoop water into carved gourds, they
spit in chewed bloodroot and burdock, they
grind dried foxglove, make tea, here. They
are about the business of revenge.
 the banshees howl

They lead the mourners to the bank, dip
ravaged bodies in primordial fresh waters, they
wash hair, feet, and hands with rough palms, they
kiss here, where poisoned rods sliced ripe succulents. They
are about the business of rebirth.
 the cicadas cry in dark corners

They build piles of stones in wait, here
at the mouth of bridges suspended over the river, they
paint war faces with charcoaled clay and goat's blood, they
sharpen machetes, scythes, buck knives and ulus. They
are about the business of reckoning.
 drums rumble & the shekeres dance

The ancient ones circle the new souls then
raise withered hands and hoarse voices
chant fevered prayers in night winds, a battle cry

to forgotten Gods . . . but the sleeping marrow
remembers . . . and sings oil into fossiled joints
that break, swing, wind hips slip into the
reverie, and calloused heels stomp aching shadows
into dust, and backs bend and arch and stretch
towards the moon like serpent heads.
 the mist rolls in.
And vamp glittered nails dig four feet wide
six feet deep trenches to bury the past.
Light matches on the heaped mounds
scorch the earth, they shout out the names
and peel off the tainted skins pocked with scars
of malicious men they, dive head-first into the flames
Ropes, ignited locks whip glowing hot embers
red eyed fireflies, into the night air. Teasing,
twinkling above the stench of burning sin.

 & the Blood Moon weeps

The new souls strut from the fire
lick the ashes from their teeth
with scorched tongues slowly
grin. Then wet their fingers to
run them here, here, & here
over the healed parts.

The Aje light cane pipes and laugh
pull them close, rub honey salve
over bellies & buttocks. Over mountain-
ous hips they slip waistbeads laced with
amber, black tourmaline, & jumbie beads
. . . just in case.

The babies suckle on rejuvenated
apricot breasts, swollen life sources
while the Great Mothers feed
on sweet breads & mead, wine &

blood oranges, round as midnight
moons shedding juicy red tears.

They all settle here.
cross-legged and sleeping
windblown and dancing
making love next to four by six-foot trenches
dug with shimmering vamp nails and need. They
all settle here in wait.

Sharpening machetes
and scythes
and buck knives
and ulus, on the stones
piled high at the mouth of bridges
suspended over primordial fresh
water rivers, waiting for the others to cross
hoping
for the familiar.

The Coon Show

The Coon Show: Act I

<div align="right">

SCENE I
</div>

 [cue thunder]

The wave comes down with the weight of a breaking nation. This is so because there is nothing before or after—the first noise, a mountain of chained birds, which is to say wailing which is to say singing, which is to say being beaten, or filled with spirits who take their pain like

 [lightning] *thieves with white faces* *pilfering.*

 [thunder]

The water dumps corpses onto the stage illuminated feathers make their passage from the fly loft. In the dark the audience is absence, the color: nothing reflecting feathers, feathers falling into absence.

 [cue Grande Drapes]

 [lights]

The not-yet-dead tunnel through the remains and crawl downstage. They have survived, and so, broken and naked hunt for new life. In the sand one finds a pair of glasses, another a topless straw hat and loincloth.

 [thunder]
They fly off in every direction.

The white folks feed the black bird until he can't fly. They gift him a vest and hat to make him feel civilized. They gift him corn meal after meal, and sometimes the leftover hog.

They gift him Sugar, too, tell him
if he doesn't keep picking in the field they'll string him up in
the elm with the other dead.

The white folks name him Fat Crow, and though he can't fly he can make a cloud of dust—is gone by dawn.

Straw Hat and his brother Glasses Crow whistle at every white woman in the city. And the women giggle. And the crows whistle.

And then they find a brother in the street, unmoving, with a line of chalk, whiter than the woman, around him. And the white men giggle. And the crows caw.

The white men pluck the brother's plumage, unzip the skin, remove the blue-black boy curled inside. His talon-less feet. His smooth, beak-less face. His beautiful, wing-less limbs. Straw Hat and Glasses dance around the chalk drawing for days.
And the white men leave the brother's skin in the streets. And the crows take his bones to rest.

Preacher Crow watches the spirit house, but he never sees any spirits. He listens to the pastor reading to the ghost-faced people from sliced tree bark. He listens
to the singing and he wonders why

the people have no soul. He thinks sometimes the growling of the sky is the
voice of god. But when the clouds roil and pop like tar bubbles it doesn't end
in revelation. Released rain seems, to Preacher Crow, to be the opposite of
possession. An exorcism.

The pastor says

the white man hanging from the tree
is holy, a symbol. Preacher Crow can't read

but he knows a liar when he sees him.

The Coon Show: Act II

<div align="right">SCENE I</div>

 [raise curtain]

The mind is this beach—

Take this stage and fill it. The body, a robe swaddling the fistful of atoms
that make us. It is enough.

 [stage left: enter the angel Azrael, leading a string
 of men, pants sagging]

This wind

 [cue wind]

can take a man's head off. The dunes are heaps of
bullets—what the water returns.

 ✳

All night Preacher Crow went on moaning and yelling, filling with the
spirit of things unnamable. The moon sliced through purple clouds to
hear gold teeth pushing away from receding gums.

It aches still, to know the sea is not ignorable,

 the sand, for now, just sand, the sea a waving field of poppies
 beneath which black and blacker flow and flow. Along
 this beach is the mind

coming to terms with the stage— the stage, like
everything,

 momentary, cherishable

 because it is so. All night,

the deep cries dragging themselves to dry land—

 ✳

Glasses Crow flew out three days ago. He won't return. He fell into
the eye of his Orisha— the peacock, deep into the sun.

And Jim Crow drove his Cadillac back and forth
along the beach. He sold crack from his Cadillac.
Once

 his Cadillac was swallowed by sand but the sea *was not*
 ignorable,

the beach large. Larger

than the brother they named Fat Crow, who lay open
and staring through the collard greens,

through insulin induced dreams,

chanting, *There. There.*

 [dim lights]

All night Preacher Crow yells.

You ain't never seen no elephants fly.

＊

There is no room for elephants, says the sea.

＊

And overhead flaps a drone casting the shadow
of a woman carrying a torch—like a flag, the
tips of the fire waving.

We will cut down our own bodies from trees. We
will cut down our own.

[cue horns] [cue laugh track]

[applause]

Q.

One of the four Royal Stars is watching over me. Yeah, I'm blessed
in these times of nervous weather. The leaves chill in a bundle then
scatter like police, off to the next doorstep. They don't step, they don't
faze me. These jeans could hold three men. But it's just one of me,
girl. Only Son. Only Sound. Only Seer. All this green to gold to red to
orange is just theater. I'm the Real. Keep your eyes on the Navigator
of Snow and Infinite Gray. I rock these boots all year. What a storm got
to do with me? Who knows the number of strolls to heaven? Not that
I'm thinking on it. The Heavens know my real name. But you can call
me Q. Quicker than Q. But, anyway. Certain things a man keeps to
himself. Jesus wept. So I don't. The past is for people who like to play
things over and over. Me, I'm on to the next song. Listen to my own
Head Symphony, to the Royal Stars. The colors, they thrill me, they fuel
these legs.

Tim Seibles

Something Like We Did

Space is the place
—Sun Ra

You could tell they were surprised
that we still tried to build cities—
the way you and I might be amazed
that birds can build nests
without hands.

>They saw how we lived
>and made a sound like
>rain sifting a river or fire
>in heavy brush.

>>For a lot of us,
>>knowing we were *not alone*
>>brought relief from the headache
>>that had lasted
>>all our lives.

Some people were scared—the religious
held onto their books, claiming
this was all "make-believe," even
when it was undeniable:
the sixty-one ships

>stacking light in the clouds—
>emerald green at dawn,
>lavender in late afternoon—
>the engines so quiet it was
>like the sky was breathing.

>>They walked something
>>like we did, but the right foot
>>stepped twice for each step

214

of the left so it appeared
they were either testing the ground
or considering a dance.

Their skin was dark
but transparent: their hearts,
like ours but visible

and when the military began
to mobilize, all of our big weapons
turned to water and whatever
we tried with knives or guns, we
somehow ended up doing
to ourselves until it seemed
insane even to us.

Each time one of them
spoke it was like a piano
if Cecil Taylor were playing: voices
changing shape in the air
the way chimney swifts
swoop, half-turn, sling back.

But sometimes when they
stared at us, their lips shimmered
and something *long-ago*
lit their eyes—

as if *we* were a memory
of who they once had been

so they came back to Earth
to prove their existence

and mark the promise
of another world:

someplace we might actually go
if we could see inside ourselves

and trace what was there

Contributors

Dr. Grisel Y. Acosta is an associate professor at the CUNY-BCC. Her first book of poetry, *Things to Pack on the Way to Everywhere* (Get Fresh Books, 2021), is an Andrés Montoya Poetry Prize finalist. Recent work is found in *Best American Poetry, The Baffler, Acentos Journal, Kweli Journal, Red Fez, Gathering of the Tribes Magazine, In Full Color, Paterson Literary Review, MiPoesias,* and *Celebrating Twenty Years of Black Girlhood: The Lauryn Hill Reader.* She is a Geraldine Dodge Foundation Poet, a Macondo Fellow, and the editor of *Latina Outsiders Remaking Latina Identity* (Routledge, 2019).

Saida Agostini is a queer Afro-Guyanese poet whose work explores the ways that Black folks harness mythology to enter the fantastic. Saida's poetry can be found in *Barrelhouse Magazine, Hobart Pulp, Plume,* and other publications. Her first collection of poems, *let the dead in,* finalist for the 2020 New Issues Poetry Prize, will be released by Alan Squire Publishing in Spring 2022. A Cave Canem Graduate Fellow, Saida has been awarded honors and support for her work by the Watering Hole and Blue Mountain Center, as well as a 2018 Rubys Grant. She lives online at saidaagostini.com.

Born in Guthrie, Oklahoma, poet and musician **T. J. Anderson III** is the author of *Devonte Travels the Sorry Route* (Omnidawn Press, 2019), *Cairo Workbook* (Willow Books, 2014), *River to Cross* (The Backwaters Press, 2009), *Notes to Make the Sound Come Right: Four Innovators of Jazz Poetry* (University of Arkansas Press, 2004), *Blood Octave* (Flat Five Recordings, 2006), and the chapbook *At Last Round Up* (lift books, 1996). He has had fellowships with the Virginia Center for the Creative Arts (VCCA) and the MacDowell Colony. He lives in Roanoke, Virginia, and teaches at Hollins University.

Joshua Bennett is a professor of English and Creative Writing at Dartmouth College. He is the author of four books of poetry and criticism: *The Sobbing School* (Penguin, 2016)—winner of the National Poetry Series and a finalist for an NAACP Image Award—as well as *Being Property Once Myself* (Harvard University Press, 2020), *Owed* (Penguin, 2020), and *The Study of Human Life* (Penguin, 2022). In 2021, he received a Guggenheim Fellowship and a Whiting Award for Poetry and Nonfiction. Joshua lives in Massachusetts with his wife and son, Pam and August, and their family dog, Apollo 5.



Tara Betts is the author of *Break the Habit, Arc & Hue,* and the forthcoming *Refuse to Disappear.* In addition to her work as a teaching artist and mentor for young poets, she's taught at several universities. Recently, she taught poetry workshops for three years at Stateville Prison via Prison + Neighborhood Arts Project. Tara is poetry editor at the *Langston Hughes Review.*

Dexter L. Booth is the author of *Abracadabra, Sunshine* (Red Hen Press, 2021), the chapbook *Rhapsody* (Upper Rubber Boot Books, 2019), and the collection *Scratching the Ghost* (Graywolf Press, 2013). Booth's poems have been included in the anthologies *The Best American Poetry 2015, The Burden of Light: Poems on Illness and Loss* (Fuse Publishing, 2014), *The Golden Shovel Anthology Honoring Gwendolyn Brooks* (University of Arkansas Press, 2017), and *Furious Flower: Seeding the Future of African American Poetry* (Northwest University Press, 2019). His poems have also appeared in *Blackbird, Grist, Willow Springs, Bat City Review, Virginia Quarterly,* and other publications. Booth is currently a contributing editor for *Waxwing.*

Borelson is a multidisciplinary artist, wellness advocate, and tech enthusiast based in Toronto. He was featured in an afrofuturistic project called "UniverSOULS project" that he creatively directed. As a musician, he released his debut album in May 2020 titled *As Far As Eye Can See,* a hip-hop infused album with touches of afrofusion. (He also directed/produced a docuseries featuring the success stories of immigrants and first-generation Canadians called *ThisFAR.*)

Derrick Weston Brown holds an MFA from American University. He was the first Poet-in-Residence of Busboys and Poets. He has attended Cave Canem and VONA. His poems appear in many publications. His first book, *Wisdom Teeth,* was released in 2011 by PM Press. He resides in Mount Rainier, Maryland.

Nikia Chaney is the author of *us mouth* (University of Hell Press, 2018), and the anthology *San Bernardino Singing* (Inlandia, 2019). She has served as Inlandia Literary Laureate (2016–2018). She is founding editor of *shufpoetry,* an online journal for experimental poetry, and founding editor of Jamii Publishing, a publishing imprint dedicated to fostering community among poets and writers. She has won grants and fellowships from the Barbara Demings Fund for Women, Millay Colony of the Arts, and Cave Canem. Her poetry has been published in *Sugarhouse Review, 491, Iowa Review, Vinyl, Pearl, Welter,* and *Saranac.* She lives and teaches in Santa Cruz, California.

Cortney Lamar Charleston is the author of *Telepathologies* (Saturnalia Books, 2017) and *Doppelgangbanger* (Haymarket Books, 2021). He was awarded a 2017 Ruth Lilly and Dorothy Sargent Rosenburg Fellowship from the Poetry Foundation, and he has also received fellowships from Cave Canem and the New Jersey State Council on the Arts. Winner of a Pushcart Prize, his poems have appeared in *POETRY,* the *American Poetry Review,* the *Kenyon Review, Granta, The Nation,* and elsewhere. He serves as a poetry editor at *The Rumpus* and on the editorial board at Alice James Books.

Lucille Clifton (1936–2010) was the author of several collections of poetry, including *Blessing the Boats: New and Selected Poems 1988–2000* (BOA Editions, 2000), which won the National Book Award; *Good Woman: Poems and a Memoir 1969–1980* (BOA Editions, 1987), which was nominated for the Pulitzer Prize; and *Two-Headed Woman* (University of Massachusetts Press, 1980), also a Pulitzer Prize nominee, as well as the recipient of the University of Massachusetts Press Juniper Prize.

Tyree Daye is a poet from Youngsville, North Carolina, and Teaching Assistant Professor at the University of North Carolina at Chapel Hill. He is the author of two poetry collections: *River Hymns* (Copper Canyon Press, 2017), APR/Honickman First Book Prize winner, and *Cardinal* (Copper Canyon Press, 2020). Daye is a Cave Canem Fellow. He won the 2019 Palm Beach Poetry Festival Langston Hughes Fellowship and the 2019 Diana and Simon Raab Writer-in-Residence at UC Santa Barbara and was a 2019 Kate Tufts finalist. Daye was also awarded a 2019 Whiting Writers Award.

Trace Howard DePass is the author of *Self-portrait as the space between us* (PANK Books, 2018), which was a finalist for the 2019 Eric Hoffer Book Prize. He served as the editor of Scholastic's Best Teen Writing of 2017 and as the 2016 Teen Poet Laureate for the Borough of Queens. His work has been featured on screen and radio—BET Next Level, Billboard, Blavity, Poetry Foundation, Ours Poetica, and NPR's *The Takeaway*—and in print—*SAND Journal, Entropy Magazine, Sonora Review, Platypus Press, Split This Rock*, the *Poetry Project, Bettering American Poetry* (Volume 3), and Academy of American Poets Poem-A-Day series. DePass is a Poetry Foundation, Teaching Artist Project, and Poets House Fellow.

Teri Ellen Cross Davis is the author of *a more perfect Union*, published in 2021 by Mad Creek Press, an imprint of Ohio State University, and winner of the 2019 Journal/Charles B. Wheeler Poetry Prize. Her first collection, *Haint* (2016, Gival Press) won the 2017 Ohioana Book Award for Poetry. She is a member of the Black Ladies Brunch Collective. She has received fellowships to attend Cave Canem, the Virginia Center for Creative Arts, Hedgebrook, Community of Writers Poetry Workshop, and the Fine Arts Work Center in Provincetown. Her work can be read in many anthologies and journals including *Not Without Our Laughter: poems of joy, humor, and sexuality*; *Bum Rush the Page: A Def Poetry Jam*; and the following journals: *Beltway Poetry Quarterly, Mom Egg Review, Natural Bridge, Poet Lore, Harvard Review, Poetry Ireland Review*, and *Tin House*. She lives in Silver Spring, Maryland. More can be read about Teri at www.poetsandparents.com.

Najee Dorsey was born in 1973 in Arkansas. His interest in art started young, but his true art pursuit began with the mentorship of artist and activist Najjar Abdul-Musawwir in the early '90s. In 2000, he and his wife (also an artist) opened a creative space that combined art, coffee, and used books and served as his introduction to the world of art entrepreneurship. In 2005, Dorsey dedicated himself to his art full-time. His work can be found in institutional and private collections around the country. Dorsey is sometimes best known for his work with Black Art in America,

an online media platform that he founded in 2010. The site serves as a resource for artists, collectors, industry leaders, and art enthusiasts, developing a steadily growing online community that documents, preserves, and promotes the contributions of the African American arts community. The artist currently resides in Columbus, Georgia.

Karo Duro creates "visual poetry," a term she coined to describe the composition of her work. Karo's work is intended to show the observer another realm or dimension of existence. Fueled by her fascination with ancient mysticism, she showcases the bridge between technology and nature.

teri elam's poems and essays have appeared in *Prairie Schooner, Slice Magazine, Auburn Avenue,* the *Alone Together* anthology, and *An Impulse to Keep: Greenwood Art Project Memorializing the 1921 Tulsa Massacre.* A Pushcart Prize nominee and Jeff Marks Memorial Prize Honorable Mention recipient, teri has an MFA from Stonecoast and is a Cave Canem and The Watering Hole Graduate Fellow.

Tim Fab-Eme enjoys playing with poetic forms and themes of identity and the environment. He loves fishing in the Niger Delta estuaries and gardening in the rainforests; Tim hopes to revisit his abandoned prose manuscripts. He's published by the *Malahat Review, New Welsh Review, Magma, The Fiddlehead, apt, Reckoning, FIYAH, Planet in Crisis Anthology,* and others. Tim studied engineering at the Niger Delta University and is presently pursuing a BA in English Studies at the University of Port Harcourt. He lives in Rivers, Nigeria.

Rico Frederick is a creative director and the author of the book *Broken Calypsonian* (Penmanship Books, 2014), holds an MFA in Writing from Pratt Institute, and is the graphic designer for the Pulitzer Prize finalist (drama) *Stew* by Zora Howard, a Fulbright Program semifinalist, a Cave Canem Fellow, a Poets House Emerging Poets Fellow, and the first poet to represent all four original New York City poetry venues at the National Poetry Slam. Rico is a Trinidadian transplant, lives in New York, loves gummy bears, and scribbles poems on the back of maps in the hope they will take him someplace new.

Richard Garcia's poetry books include *The Other Odyssey* (Dream Horse Press, 2014), *The Chair* (BOA, 2015), and *Porridge* (Press 53, 2016). His poems have appeared in many journals and anthologies. He has won a Pushcart Prize and has been in Best American Poetry. He lives in Charleston, South Carolina.

Nikki Giovanni has been awarded seven NAACP Image Awards, a Grammy nomination, and a finalist for the National Book Award. She has authored three *New York Times* and *Los Angeles Times* best sellers. She is also a University Distinguished Professor at Virginia Tech.

Natalie J. Graham, a native of Gainesville, Florida, earned her MFA in Creative Writing at the University of Florida. She completed her PhD in American Studies at Michigan State University as a University Distinguished Fellow. Her first

poetry collection, *Begin with a Failed Body* (University of Georgia Press, 2017), was selected by Kwame Dawes for the 2016 Cave Canem Poetry Prize. She is a Cave Canem Fellow and chair of African American Studies at California State University, Fullerton (CSUF).

Ashley Harris is an African American poet from Virginia. She has her master's in biomedical sciences from Wake Forest School of Medicine and her bachelor's in chemistry from the University of North Carolina at Chapel Hill. Her goal is to incorporate medicine, nerdom, and healing into her creative projects.

Yona Harvey is the author of the poetry collections *You Don't Have to Go to Mars for Love* (Four Way Books) and *Hemming the Water* (Four Way Books), winner of the Kate Tufts Discovery Award. She contributed to Marvel's *World of Wakanda* and *Black Panther & the Crew*. She has worked with teenagers writing about mental health issues in collaboration with *Creative Nonfiction* magazine and received the inaugural Lucille Clifton Legacy Award in poetry from St. Mary's College of Maryland.

The most recent publications of poet **Terrance Hayes** include *American Sonnets for My Past and Future Assassin* (Penguin 2018) and *To Float in the Space Between: Drawings and Essays in Conversation with Etheridge Knight* (Wave, 2018).

Yorli Huff is the award-winning author of *The Veil of Victory*, an account of her life from childhood to her victory over the Cook County Sheriff's Department, published in October 2010. She has completed a five-book comic book series titled *Superhero Huff*, which includes a clothing line.

Born and raised in Topeka, Kansas, **Gary Jackson** is the author of the poetry collections *origin story* (University of New Mexico Press, 2021) and *Missing You, Metropolis* (Graywolf Press, 2010), which received the 2009 Cave Canem Poetry Prize. He's also the co-editor of *The Future of Black: Afrofuturism, Black Comics, and Superhero Poetry* (Blair, 2021). His poems have appeared in numerous journals including *Callaloo*, *The Sun*, *Los Angeles Review of Books*, and *Copper Nickel*. The recipient of Cave Canem and Bread Loaf fellowships, he's also been published in *Shattered: The Asian American Comics Anthology* and was featured in the 2013 New American Poetry Series by the Poetry Society of America. He's an associate professor at the College of Charleston, where he teaches undergraduate creative writing and in the MFA program, and serves as an associate poetry editor at *Crazyhorse*.

Les James is an emerging multimedia artist and writer. She identifies as a Black cis-female person of the global majority and currently resides on the occupied lands of the Powhatan Confederacy (Richmond, Virginia). Her love of sci-fi fantasy was cultivated in early childhood by Robotech anime and the Ultima computer games series. She enjoys long walks and spicy food. Her website is www.mallessa.com.

Rashida James-Saadiya is a writer and cultural educator who uses Afrofuturism to explore Black women's contemporary and historical experiences in America. Her poetry has appeared in *Amaliah, Hand to Hand: Poets Respond to Race*, and *A Kaleidoscope of Stories: Muslim Voices in Contemporary Poetry*. Her essays have appeared in *Sapelo Square* and *Voyages Africana Journal*.

John Jennings is a professor of Media and Cultural Studies at the University of California at Riverside. His work centers around intersectional narratives regarding identity politics and popular media. Jennings is co-editor of the Eisner Award–winning collection *The Blacker the Ink: Constructions of Black Identity in Comics and Sequential Art* and cofounder/organizer of the Schomburg Center's Black Comic Book Festival in Harlem. He is cofounder and organizer of the MLK NorCal's Black Comix Arts Festival in San Francisco and also SOL-CON: The Brown and Black Comix Expo at the Ohio State University. Jennings is currently a Nasir Jones Hip Hop Studies Fellow with the Hutchins Center at Harvard University. Jennings's current comics projects include the hip-hop adventure comic *Kid Code: Channel Zero*, the supernatural crime noir story *Blue Hand Mojo*, and the upcoming graphic novel adaptation of Octavia Butler's classic dark fantasy novel *Kindred*. His and Damian Duffy's adaptation of Octavia Butler's book *Parable of the Sower* has been nominated for the Eisner Award for Best Adaptation and the Hugo Award for Best Graphic Story.

Kevin Johnson is a Colorado-based painter, concept artist, graphic designer, sculptor, and animator known for his striking employment of vibrant colors and depictions of everyday people progressing, evolving through life. A native of Louisville, Kentucky, Johnson pulls his images from childhood memories, life experiences, and his active imagination, with friends and family inspiring several works. A retired twenty-one-year member of the U.S. Army who actively served in Iraq and Afghanistan, Johnson graduated with a BS in computer animation from Full Sail University before returning to school to study media design. His gallery appearances include shows at Colorado's Southwinds Fine Art Gallery, G44 Gallery, Bella Art Gallery, the Beauty of Blackness Fine Art Show, and the historic 2011 reopening of the Houston Museum of African American Culture (HMAAC) as part of the exhibition "Fresh and Contemporary: Moving Forward." Johnson, whose work has been purchased by the likes of celebrity collector and former NBA baller Grant Hill, lives in Colorado Springs with his wife and six children.

Amanda Johnston earned a Master of Fine Arts in Creative Writing from the University of Southern Maine. She is the author of two chapbooks, *GUAP* and *Lock & Key*, and the full-length collection *Another Way to Say Enter*. Her poetry and interviews have appeared in numerous online and print publications, among them *Callaloo*; *Poetry*; *Puerto del Sol*; *Muzzle*; *Pluck!*; *No, Dear*; and the anthologies *Small Batch, Full, di-ver-city, The Ringing Ear: Black Poets Lean South*, and *Women of Resistance: Poems for a New Feminism*. Honors include the Christina

Sergeyevna Award from the Austin International Poetry Festival, a joint finalist for the Freedom Plow Award for Poetry & Activism from Split This Rock, and multiple Artist Enrichment grants from the Kentucky Foundation for Women. Amanda is a member of the Affrilachian Poets and has received fellowships from the Cave Canem Foundation and the Austin Project at the University of Texas. Johnston is a Stonecoast MFA faculty member, a cofounder of Black Poets Speak Out, and founder/executive director of Torch Literary Arts.

Ashley M. Jones is the author of *Magic City Gospel*, *dark//thing*, and the forthcoming *REPARATIONS NOW!* She is the founding director of the Magic City Poetry Festival, and she teaches in Birmingham, Alabama.

Quincy Scott Jones is the author of two books of poetry: *The T-Bone Series* (Whirlwind Press, 2009) and *How to Kill Yourself Instead of Your Children* (C&R Press, 2021). His work has appeared in the *African American Review*, the *North American Review*, the *Bellingham Review*, *Love Jawns: A Mixtape*, and *The Feminist Wire*. With Nina Sharma, he co-curates Blackshop, a column that thinks about allyship between BIPOC artists. His graphic narrative, >Black Nerd<, is in the works.

A. Van Jordan is the author of four collections: *Rise*, which won the PEN/Oakland Josephine Miles Award (Tia Chucha Press, 2001); *M-A-C-N-O-L-I-A* (2005), which was listed as one the Best Books of 2005 by the *London Times*; *Quantum Lyrics* (W. W. Norton, 2007); and *The Cineaste* (W. W. Norton, 2013). Jordan has been awarded a Whiting Writers Award, an Anisfield-Wolf Book Award, and a Pushcart Prize. He is also the recipient of a John Simon Guggenheim Fellowship and a United States Artists Fellowship. He is the Henry Rutgers Presidential Professor at Rutgers University-Newark.

Alice M. Kandolo is a seventeen-year-old self-taught multidisciplinary artist. Her work surrounds world issues, fantasies, and controversial topics.

Douglas Kearney has published six books, most recently, *Buck Studies* (Fence Books, 2016), winner of the Theodore Roethke Memorial Poetry Award, the CLMP Firecracker Award for Poetry, and silver medalist for the California Book Award (Poetry). *BOMB Magazine* says: "[Buck Studies] remaps the 20th century in a project that is both lyrical and epic, personal and historical." M. NourbeSe Philip calls Kearney's collection of *libretti*, *Someone Took They Tongues* (Subito, 2016), "a seismic, polyphonic mash-up that disturbs the tongue." Kearney's collection of writing on poetics and performativity, *Mess and Mess and* (Noemi Press, 2015), was a Small Press Distribution Handpicked Selection that *Publisher's Weekly* called "an extraordinary book." *Starts Spinning* (Rain Taxi), a chapbook of poetry, saw publication in 2019. His seventh collection, *Sho* (Wave) was published in April 2021. *Fodder*, an LP featuring Kearney and frequent collaborator/SoundChemist Val Jeanty was published by Fonograf Editions (2021).

Maurya Kerr is an Oakland-based writer, educator, and artist. Much of her artistic work is focused on Black and brown people reclaiming their birthright to

wonderment. Her poetry has appeared or is forthcoming in *Hole in The Head Review*, *Blue River Review*, *River Heron Review*, *Inverted Syntax*, and *Chestnut Review*.

Len Lawson is the author of *Chime* (Get Fresh Books, 2019). He is also co-editor of *Hand in Hand: Poets Respond to Race* (Muddy Ford Press, 2017). His poetry has been nominated for the Pushcart Prize and Best of the Net. He has received fellowships from Callaloo, Vermont Studio Center, Virginia Center for the Creative Arts, and others. His poetry appears in *African American Review*, *Callaloo*, *Mississippi Review*, *Ninth Letter*, *Verse Daily*, *Yemasee*, and elsewhere.

Steven Leyva was born in New Orleans, Louisiana, and raised in Houston, Texas. His poems have appeared or are forthcoming in *2 Bridges Review*, *Scalawag*, *Nashville Review*, *jubilat*, *Vinyl*, *Prairie Schooner*, and *Best American Poetry 2020*. He is a Cave Canem Fellow and author of the chapbook *Low Parish* and author of *The Understudy's Handbook*, which won the Jean Feldman Poetry Prize from Washington Writers Publishing House. Steven holds an MFA from the University of Baltimore, where he is an assistant professor in the Klein Family School of Communications Design.

Cagen Luse is a visual artist and entrepreneur. He is the artist and author of two comic series, *LunchTime ComiX* (lunchtimecomix.com) and *The Market*. They have been published in the local alt-weeklies *DIG Boston* and the *Boston Compass*, as well as various social media platforms. He also runs his own business, 95odesign (95odesign.com), which produces handmade items such as tee shirts, art prints, buttons, and note cards featuring his original artwork. Cagen is also the cofounder of Comics in Color and the Boston Comics in Color Festival (comicsincolor.org), a monthly meet-up event series and a comic arts festival for enthusiasts, artists, and writers of comics by and about people of color.

Terese Mason Pierre is a poet and writer whose work has appeared in *Strange Horizons*, *FIYAH Magazine*, *The Puritan*, and elsewhere online and in print. She is the senior poetry editor of *Augur Magazine* and the author of the chapbooks *Surface Area* (Anstruther Press, 2019) and *Manifest* (Gap Riot Press, 2020). She lives in Toronto, Canada. Visit her website at www.teresemasonpierre.com.

Cynthia Manick is the author of *Blue Hallelujahs* (Black Lawrence Press, 2016) and editor of *Soul Sister Revue: A Poetry Compilation* (Jamii Publishing, 2019) and *The Future of Black: Afrofuturism, Black Comics, and Superhero Poetry* (Blair, 2021). She has received fellowships from Cave Canem, Hedgebrook, MacDowell Colony, and Château de la Napoule, among others. Winner of the Lascaux Prize in Collected Poetry, Manick is also founder of the quarterly reading series Soul Sister Revue. A performer at literary festivals, libraries, universities, and, most recently, the Brooklyn and Frye museums, Manick's work has appeared in the Academy of American Poets *Poem-A-Day Series*, *Callaloo*, *Los Angeles Review of Books* (*LARB*), the *Wall Street Journal*, and elsewhere. She currently serves on the board of the International Women's Writing Guild and the editorial board of Alice James Books.

Yvonne McBride is a literary artist, freelance writer, and oral historian based in her native Pittsburgh, Pennsylvania. Her work sits at the intersection of collective memories, identity, folklore, and culture of her hometown and the African diaspora. A recipient of the Advancing Black Arts in Pittsburgh funds, from the Pittsburgh Foundation and Heinz Endowments, McBride has received fellowships from MacDowell and Voices of Our Nations Arts Foundation, as well as support from the Hurston/Wright, Callaloo, and Sewanee writing communities.

Wolly McNair is a founding member of the art collective GOD City. Wolly displayed work in art shows, working to redefine the idea of "fine art." His work has been displayed in the Mint Museum of Charlotte, the Harvey B. Gantt Center for African-American Arts, the worldwide PechaKucha event, the Museum of Art Columbia, Johnston C. Smith University, Appalachian State University, the University of North Carolina at Charlotte, the Art Institute of Charlotte, Green Rice Gallery, Art House Galleries, and as a continued part of Art Beats and Lyrics by Jack Daniels. Wolly has been a character concept artist and comic/ graphic novel illustrator. His design work includes packaging and visuals for promotional projects and murals, and he dedicates his time to many programs, including workshops to educate and inform others.

Tony Medina, two-time winner of the Paterson Prize for Books for Young People (*DeShawn Days* and *I and I, Bob Marley*), is a poet, graphic novelist, editor, short story writer, and the author/editor of twenty-three books for adults and young readers, the most recent of which are *Death, with Occasional Smiling, Thirteen Ways of Looking at a Black Boy* (recipient of the Lee Bennett Hopkins Award honor), the graphic novel *I Am Alfonso Jones*, as well as the anthology *Resisting Arrest: Poems to Stretch the Sky*. Medina, who has received the Langston Hughes Society Award, the first African Voices Literary Award, and was nominated for Pushcart Prizes for his poems "Broke Baroque" and "From the Crushed Voice Box of Freddie Gray," holds an MA and PhD from Binghamton University, SUNY, and is the first professor of creative writing at Howard University. His poetry, fiction and essays appear in over 100 journals and anthologies, including Sheree Renée Thomas's *Dark Matter*, Ishmael Reed's *Hollywood Unchained*, and Kevin Young's Library of America anthology, *African American Poetry: 250 Years of Struggle and Song*, and as an advisory editor for Nikki Giovanni's *Hip Hop Speaks to Children*.

Jamal Michel is a writer and educator out of North Carolina. After spending five years in the classroom, he decided to pursue creative writing unabashedly. His work and commentary have been heavily influenced by his Afro-Caribbean roots, and his most recent undertaking is an Afrofuturist comic he's hoping to turn into a full series with the help of a Kickstarter. He's been featured in the *Missouri Review*, *Apogee Journal*, and *Linden Avenue Journal*, to name a few.

Turtel Onli is an American artist, entrepreneur, author, art therapist, educator, and publisher.

Glenis Redmond is a nationally renowned award-winning poet and teaching artist. In 2020 she became a recipient of South Carolina's highest award, the Governor's Award for the Arts. Glenis is a Kennedy Center Teaching Artist and a Cave Canem poet and has been the mentor poet for the National Student Poets Program since 2014. Her latest book, *The Listening Skin*, will be published by Four Way Books in 2022.

Casey Rocheteau was born on Cape Cod and raised as a sea witch. They are an author and visual/sound artist living in Detroit, Michigan. In 2014, Rocheteau created the Shrine of the Black Medusa Tarot. Their second poetry collection, *The Dozen*, was released by Sibling Rivalry Press in 2016. Winner of inaugural Write a House permanent residency in 2014, Rocheteau resides in a home they won with poems. They are a Callaloo Writer's Workshop, Cave Canem, and Bread Loaf Writers' Conference fellow. They currently serve as the communications manager of the Detroit Justice Center.

Peter Schmidt teaches U.S. literature and offers classes in poetry (including Spoken Word) at Swarthmore College, near Philadelphia. He also contributes courses to Swarthmore's interdisciplinary Black Studies program.

Gil Scott-Heron (1949–2011) was a poet, author, musician, and spoken word artist in Harlem, New York.

Tim Seibles lives in Norfolk, Virginia. *Fast Animal*, his fifth collection of poems, was a National Book Award Finalist in 2021 and winner of the Theodore Roethke Memorial Poetry Prize. He recently completed a two-year term as the poet laureate of Virginia.

Tracy K. Smith is the author of four poetry collections, including *Wade in the Water* (Graywolf Press, 2018), winner of the 2019 Anisfield-Wolf Book Award in Poetry and shortlisted for the 2018 T. S. Eliot Prize. Her debut collection, *The Body's Question* (Graywolf Press, 2003), won the Cave Canem Poetry Prize in 2002. Her second book, *Duende* (Graywolf Press, 2007), won the 2006 James Laughlin Award from the Academy of American Poets. Her collection *Life on Mars* (Graywolf Press, 2011) won the 2012 Pulitzer Prize for Poetry. She also edited the anthology *American Journal: Fifty Poems for Our Time* (Graywolf Press, 2018). Her fifth collection, *Such Color: New and Selected Poems*, is forthcoming from Graywolf Press in October 2021. In 2017, Smith was appointed Poet Laureate of the United States.

Craig Stevens (@mrblackatlantic) is an artist academic who writes and curates around themes of transcultural Blackness, freedom making, and radical solidarity. He is cofounder of the Black & African Solidarity Show (B.A.S.S.) and a doctoral student in the Northwestern University Anthropology Department.

Sheree Renée Thomas is the author of *Nine Bar Blues: Stories from an Ancient Future* (Third Man Books, 2020), *Sleeping Under the Tree of Life* (Aqueduct Press), longlisted for the 2016 Otherwise Award and honored with a PW Starred Review,

and *Shotgun Lullabies* (2011). Her work is widely anthologized and appears in *The Big Book of Modern Fantasy*, the *New York Times*, *Marvel's Black Panther: Tales of Wakanda*, and is forthcoming in *The Year's Best Dark Fantasy and Horror*. Sheree is the editor of the *Magazine of Fantasy & Science Fiction*, founded in 1949, and associate editor of *Obsidian: Literature & Arts in the African Diaspora*, founded in 1975. Sheree lives in Memphis, Tennessee, near a mighty river and a pyramid. Visit http://www.shereereneethomas.com.

Khalif Tahir Thompson is best recognized for his powerful work concentrated in portraiture and figuration. Incorporating painting, drawing, collage, printmaking, and paper-making into his practice, he explores notions of self through varied subjectivity concerning identity, race, iconography, as well as family and relationships. Recently he graduated from Purchase College with his bachelor's in fine arts degree and completed a fellowship at the EFA Robert Blackburn Printmaking Workshop in New York City, the Vermont Studio Center, and received a 2021 NYFA Fellowship in Painting. He is currently represented by Black Art in America LLC.

Anastacia-Renee Tolbert is a writer, educator, interdisciplinary artist, TEDx speaker, and podcaster. Renee is the author of *(v.)*, (Black Ocean), *Forget It* (Black Radish), and *26* (Dancing Girl Press) and has received fellowships and residencies from Cave Canem, Hedgebrook, VONA, Ragdale, Mineral School, and the New Orleans Writers Residency. Her poems and essays have been anthologized in *Furious Flower: Seeding the Future of African American Poetry*, *Spirited Stone: Lessons from Kubota's Garden*, and *Seismic: Seattle City of Literature*, and her poetry and fiction have appeared in *Obsidian, Foglifter, Auburn Avenue, Catapult, Alta, Torch*, and many more. https://www.anastacia-renee.com/

upfromsumdirt is a poet and visual artist living in Lexington, Kentucky. He is the author of two poetry collections, *Deifying a Total Darkness* and *To Emit Teal*. The featured poems are from his unpublished collection based in mythology and afro-futurism, *The Second Stop Is Jupiter*.

Lyrae Van Clief-Stefanon is the author of *] Open Interval [*, a 2009 finalist for the National Book Award and the LA Times Book Prize, and *Black Swan*, winner of the 2001 Cave Canem Poetry Prize. She has been awarded fellowships from Cave Canem, the Lannan Foundation, and Civitella Ranieri. She has written plays and lyrics for The Cherry, an Ithaca arts collective, and in 2018, her work was featured in "Courage Everywhere," celebrating women's suffrage and the fight for political equality, at National Theatre London.

Recipient of a 2010 Governor's General Award and creator of the Joshua Glover memorial—Toronto's first monument of a person of African descent—**Quentin VerCetty** is a multi-award-winning multidisciplinary a-r-tographer (artivist/research/educator) and Afrofuturist. As a self-described visual griot (a West African term for storyteller), "artpreneur," and as an "ever-growing interstellar tree," he is one of the world's leading Afrofuturist artists. VerCetty is the first-ever visual artist

commissioned by Carnegie Hall to create a signature work of art to represent Carnegie Hall Festivals, along with being one of the founding leaders of the global Black Speculative Arts Movement, launching the Canadian chapter in 2016. VerCetty's personal work looks at Afrofuturism as a teaching tool, coining the terms *Sankofanology* as a lens and *Rastafuturism* as a concept. His creative works speculate on addressing social issues and the imaginative futures of representation and preservation of the memories of people of African descent.

The first African American writer to be named Kentucky Poet Laureate, **Frank X Walker** is a professor of English and African American and Africana Studies at the University of Kentucky in Lexington, where he founded *pluck! The Journal of Affrilachian Arts & Culture*. He has published eleven collections of poetry, including *Turn Me Loose: The Unghosting of Medgar Evers*, which was awarded an NAACP Image Award and the Black Caucus American Library Association Honor Award. He is also the author of *Buffalo Dance: The Journey of York*, winner of a Lillian Smith Book Award, and *Isaac Murphy: I Dedicate This Ride*. Walker coined the term "Affrilachia" and cofounded the Affrilachian Poets. A Cave Canem Fellow, his honors also include a Lannan Literary Fellowship for Poetry.

Loretta Diane Walker, a member of the Texas Institute of Letters, is a Best of the Net nominee and a nine-time Pushcart nominee, won the 2021 William D. Barney Memorial Chapbook Contest sponsored by the Fort Worth Poetry Society, the 2016 Phillis Wheatley Book Award, and the 2011 Bluelight Press Book Award.

Moriah S. Webster is a born and bred Tarheel living in Harlem. She enjoys writing poetry and prose in English and Spanish. She has two published short stories, "Glosolalia" and "Head Over Heels." They are online in *Aguas del Pozo/Waters of the Well* and *Deep South Magazine*.

Rodney Wilder is a biracial nerd who bellows death-metal verse in Throne of Awful Splendor and writes poetry, with work appearing in places like *Half Mystic*, *Anti-Heroin Chic*, and *FreezeRay*, as well as his newest, nerd-themed collection *Stiltzkin's Quill*. He likes nachos, analogizing things to *Pokémon*, and getting lost in Oregonian forests with his co-meanderer. Find him on Instagram at @thebardofhousewilder.

Keith S. Wilson is an Affrilachian Poet and a Cave Canem Fellow. He is a recipient of an NEA Fellowship, an Elizabeth George Foundation Grant, and an Illinois Arts Council Agency Award, and has received both a Kenyon Review Fellowship and a Stegner Fellowship. Additionally, he has received fellowships or grants from Bread Loaf, Tin House, and the MacDowell Colony, among others. His book, *Fieldnotes on Ordinary Love* (Copper Canyon), was recognized by the *New York Times* as a best new book of poetry.

Bianca X (Bianca Lynne Spriggs) is an award-winning poet and playwright from Kentucky. An Affrilachian poet and Cave Canem Fellow, she is an assistant professor of English at Ohio University. Her work has been widely anthologized and

included in many publications, including *POETRY, Oxford American, Obsidian,* and others. Bianca X is the author of five collections of poetry, *Black Mermaid* (Argus House Press, 2018), and the co-editor of three poetry anthologies, most recently, *Black Bone: 25 Years of the Affrilachian Poets* (University of Kentucky Press, 2018).

Interdisciplinary artist and educator **avery r. young** is a 3Arts Awardee and one of four executives for the Floating Museum. His poetry and prose are featured in several anthologies and periodicals including *Berkeley Poetry Review 49, Poetry Magazine,* and photographer Cecil McDonald Jr.'s *In the Company of Black.* He is the featured vocalist on flautist Nicole Mitchell's *Mandorla Awakening* (FPE Records) and is currently touring with her Black Earth Ensemble and his funk/soul band de deacon board. young's latest full-length recording *tubman* (FPE Records) is the soundtrack to his first collection of poems, *neckbone: visual verses* (Northwestern University Press).

Afrofuturism Syllabus Resources

SHORT STORY COLLECTIONS

Henry Dumas, *Echo Tree*, 2003, & *Ark of Bones*, 1970

Sheree Renée Thomas, ed., *Dark Matter: A Century of Speculative Fiction from the African Diaspora*, 2001, & *Nine Bar Blues*, 2020

S. Andrea Allen & Lauren Cherelle, eds., *Black from the Future: A Collection of Black Speculative Writing*, 2019

James L. Wolf & Hartmut Geerken, eds., *Sun Ra: The Immeasurable Equation. The Collected Poetry and Prose*, 2006

POETRY COLLECTIONS

Adam Everett Abraham, ed., *Sun Ra: Collected Works Vol. 1—Immeasurable Equation*, 2005

Gary Jackson, *Missing You, Metropolis*, 2010

Tracy K. Smith, *Life on Mars*, 2011

Danez Smith, *Black Movie*, 2015

Yona Harvey, *You Don't Have to Go to Mars for Love*, 2020

NOVELS

Octavia Butler, *Kindred*, 1979, & *Parable of the Sower*, 1993

Ishmael Reed, *Mumbo Jumbo*, 1972

Buchi Emecheta, *The Rape of Shavi*, 1983

Toni Morrison, *The Bluest Eye*, 1970, & *Beloved*, 1987

Nnedi Okorafor, *Lagoon*, 2014

Samuel R. Delaney, *Dhalgren*, 1974

Colson Whitehead, *The Intuitionist*, 1999, & *The Underground Railroad*, 2016

Matt Ruff, *Lovecraft Country*, 2016

N. K. Jemisin, *The Broken Earth Trilogy*, 2015–2017

A. Igoni Barrett, *Blackass*, 2015

COMICS

Spawn, 1992

Black Panther, 1966

Black Lightning, 1977

Luke Cage, 1972
Spider-Man: Miles Morales, 2020
Suicide Squad: Amanda Waller, 2014
Yona Harvey, Ta-Nehisi Coates, & Butch Guice, *Black Panther & The Crew,* 2017
G. Willow Wilson & Adrian Alphona, *Ms. Marvel (Volume 1),* 2014
David Walker & Sanford Greene, *Bitter Root Volume 1,* 2019

NEW COMICS RESOURCES

Frances Gateward & John Jennings, eds., *The Blacker the Ink: Constructions of
Black Identity in Comics and Sequential Art,* 2015
Jesse Holland, ed., *Black Panther: Tales of Wakanda,* 2021
Geoff Johns, Len Wein, & Dave Gibbons, *Green Lantern: John Stewart—
A Celebration of 50 Years,* 2021

SCHOLARLY WORKS/CRITICISM

Mark Dery, ed., *Flame Wars: The Discourse of Cyberculture*
Ytasha Womack, ed., *Afrofuturism: The World of Black Sci-fi and Fantasy Culture*
Reynaldo Anderson & Charles Earl Jones, eds., *Afrofuturism 2.0: The Rise of
Astro-Blackness*
Sheena C. Howard, *Black Comics: Politics of Race and Representation,* 2013
——, *Encyclopedia of Black Comics,* 2017
——, ed., *Why Wakanda Matters: What Black Panther Reveals about Psychology,
Identity, and Communication,* 2021
Jacqueline Ellis, Jason D. Martinek, & Sonya Donaldson, "Understanding the
Past, Imagining the Future: Teaching Speculative Fiction and Afrofuturism,"
Transformations, https://www.jstor.org/stable/10.5325/trajincschped.28.1.0111
?seq=1
Reynaldo Anderson, "AFROFUTURISM 2.0 & THE BLACK SPECULATIVE
ARTS MOVEMENT: Notes on a Manifesto," *Obsidian,* vol. 42, no. 1/2, 2016,
228–36, www.jstor.org/stable/44489514
"25 Years of Afrofuturism and Black Speculative Thought: Roundtable with
Tiffany E. Barber, Reynaldo Anderson, Mark Dery, & Sheree Renée Thomas,"
TOPIA: Canadian Journal of Cultural Studies, vol. 39, 2018, 136–44, muse.jhu
.edu/article/706962
Hope Wabuke, "Afrofuturism, Africanfuturism, and the Language of Black Specu-
lative Literature," *Los Angeles Review of Books,* 2020, https://lareviewofbooks.org
/article/afrofuturism-africanfuturism-and-the-language-of-black-speculative
-literature/
Anais Duplan, *Blackspace: On the Poetics of an Afrofuture,* 2020

FILMS

Space Is the Place, 1974
The Watermelon Man, 1970
The Wiz, 1978

Blacula, 1972
Star Wars Saga, 1978–2019
Barry Gordy's The Last Dragon, 1985
Vampire in Brooklyn, 1995
Moonwalker, 1988
The Meteor Man, 1993
Mad Max Beyond Thunderdome, 1985
Tales from the Hood, 1995
Spawn, 1997
Space Jam, 1996
The Fifth Element, 1997
The Matrix Saga, 1999–2003
Deep Impact, 1998
Beloved, 1998
Independence Day, 1996
Wild Wild West, 1999
Men in Black Saga, 1997–2019
The Nutty Professor, 1996
I, Robot, 2004
I Am Legend, 2007
Hancock, 2008
Bright, 2017
Marvel's Black Panther, 2018
Blade Trilogy, 1998–2004
The Brother from Another Planet, 1984
A Wrinkle in Time, 2018
Us, 2019
Jingle Jangle, 2020
Antebellum, 2020
Tenet, 2020

TV

Star Trek, 1966–1969
Star Trek: The Next Generation, 1987–1994
Homeboys in Outer Space, 1996–1997
Static Shock, 2000–2004
Afro Samurai, 2007
Black Mirror, 2011–2019
Luke Cage, 2016–2018
The Walking Dead, 2010–2022
Westworld, 2016–
Black Lightning, 2018–2021
Lovecraft Country, 2020
Them, 2021

ALBUMS

Earth, Wind, and Fire Discography
Michael Jackson, *Thriller*, 1982
OutKast, *ATLiens*, 1996, & *Stankonia*, 2000
Parliament, *Mothership Connection*, 1975
Funkadelic, *One Nation Under a Groove*, 1978
Missy Elliot, *Supa Dupa Fly*, 1997
Beyonce, *Lemonade*, 2016, & *Black Is King*, 2020
Travis Scott, *Astroworld*, 2018
Janelle Monte, *Dirty Computer*, 2018
Kendrick Lamar, *Black Panther Soundtrack*, 2018

VIDEO GAMES

Moonwalker, 1990
Def Jam Vendetta, 2003
Spawn: Armageddon, 2003
The Walking Dead: The Telltale Series, 2012–2019
Marvel's Spider-Man: Miles Morales, 2020

ART

Najee Dorsey, *Poor People's Campaign* series
Cyrus Kabiru, *C-stunners Sculptural Eyewear* series
Wangechi Mutu, *A Fantastic Journey* series
Joshua Mays, murals
John Jennings, *Matterz of the Fact* series
Rasheeda Phillips, *Black Quantum Futurism/Moor Mother* series/theory

OTHER RESOURCES

Langston League's Unofficial Lovecraft Country Syllabus, https://langstonleague
 llc.squarespace.com/popculturepd
Zora! Festival 2020–2021 Afrofuturism Syllabus, https://stars.library.ucf.edu
 /afrofuturism_syllabus/
Tyechia L. Thompson & Dashiel Carrera, "Afrofuturist Intellectual Mixtapes:
 A Classroom Study," *Digital Humanities Quarterly*, http://www.digitalhumanities
 .org/dhq/vol/15/1/000516/000516.html